BEGINNER'S GUIDE TO
Glass Painting

ISBN 978-1-4971-0306-1

Library of Congress Control Number: 2023936029

Project Team
Managing Editor: Gretchen Bacon
Acquisitions Editor: Amelia Johanson
Editor: Christa Oestreich
Designers: Mike Deppen, Wendy Reynolds, and Freire Disseny + Comunicació
Proofreader: Jeremy Hauck
Indexer: Jay Kreider

Shutterstock used: photo-nuke (flower background, used throughout); studioflara (pink background, front cover); Peter Radacsi (9 left); RimDream (26); Natalia Skripko (118, 121); benntennsann (120); Suwi19 (122); floralpro (123); luChi (125); Kotkoa (126); Katika (127); IrinaKrivoruchko (128); Aluna1 (129 top); cgterminal (129 bottom); volcebyyou (130); Epine (131); Oksana Alekseeva (132); troyka (133).

To learn more about the other great books from Fox Chapel Publishing, or to find a retailer near you, call toll-free 800-457-9112 or visit us at *www.FoxChapelPublishing.com*.

We are always looking for talented authors. To submit an idea, please send a brief inquiry to acquisitions@foxchapelpublishing.com.

Printed in the USA

BEGINNER'S GUIDE TO
Glass Painting

16 Amazing Projects for
Picture Frames, Dishware,
Mirrors, and More!

Nilima Mistry

FOX CHAPEL
PUBLISHING

Contents

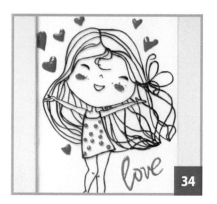

34

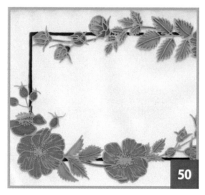

50

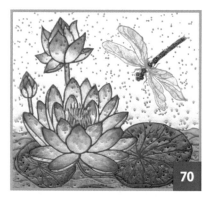

70

94

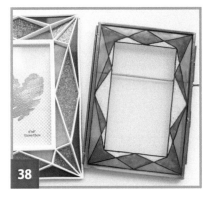

38

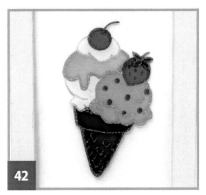

42

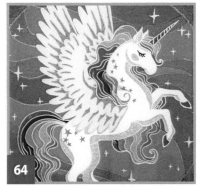

46

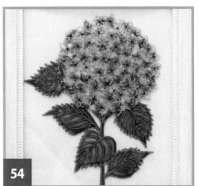

54

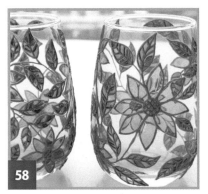

58

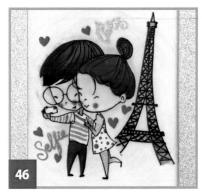

64

76

82

88

100

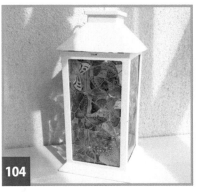

104

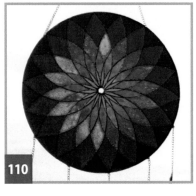

110

Introduction

Glass painting turns plain mirrors, picture frames, drinking glasses, and more into beautiful items suited to your taste and style. And it's easier than it looks! This book introduces the tools and paints you will need to get started, plus some options if you want to experiment in the future. With your materials in hand, you'll learn how to use them as you make each project. These 16 projects are perfectly designed to build your skills and experience level, each one teaching a new technique that is a valuable tool for those familiar with painting or a total beginner. At the end, you will have a piece perfect to display or give as a gift. Before you know it, you'll be a glass-painting master.

We use glass every day because it provides an unobstructed view, but it's easy to forget that glass is a great medium to decorate. Its greatest strength as a painting medium is being transparent because you can easily trace patterns or original art below. There are 16 pages of templates in this book to get you started, but you can easily find more to make endless pieces you'll love for a lifetime.

This book demonstrates the objects you can paint. Simply browsing through a craft or home-goods store can inspire you. It's easy to add glitter that will add even more sparkle when hit by the sun. Blending colors on the glass surface will quickly become a tool in your arsenal to make any piece more realistic. The possibilities are endless!

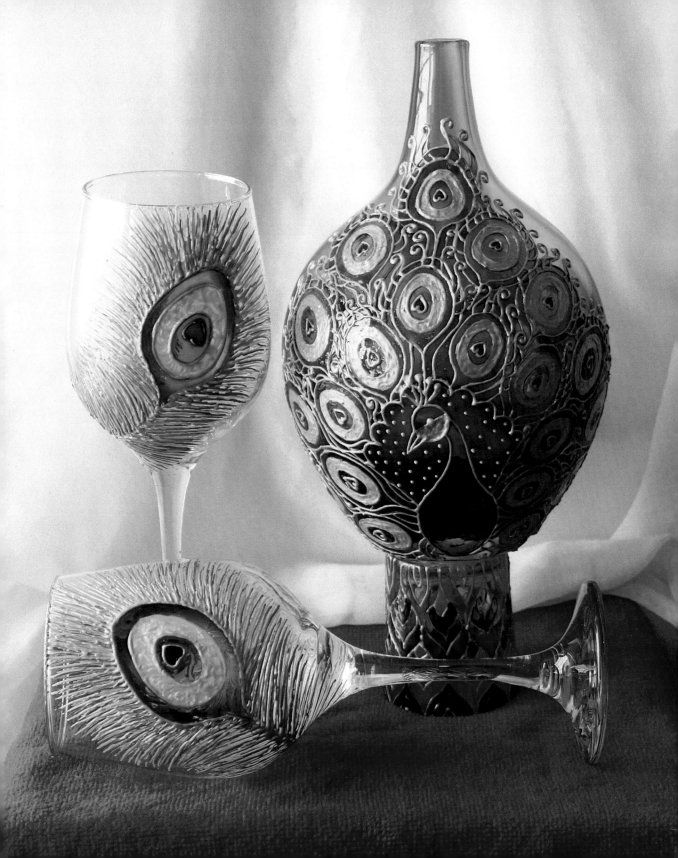

What Is Glass Painting

Glass painting is a style of painting usually done on glass using brilliant glass colors and glass liners. They give the glass a semi-transparent, colorful effect; hence, a painting done on glass is called glass painting. Glass painting can be easily made at home using a simple glass-painting kit by any person who desires to make it, hobbyist or artist. The results are often compared to stained glass, though this process is quite different in execution.

Artists in 16th century Europe first developed this painting technique. Because glass was very expensive to make, any artist using it was commissioned by the nobility or churches. For a long time, the only images seen would be religious iconography or portraits. Merchants brought glass painting to Asia during the 18th century, where the focus shifted more to natural elements like flowers, birds, and landscapes.

As glass became cheaper and more widely available, glass painting picked up momentum as a folk art. It's drifted in and out of popularity over the centuries, but there's no denying the beautiful results that can be seen around the world.

Glass painting bears a striking resemblance to stained glass. This is because glass painting is essentially an offshoot of this older form of glass coloring, though it is made by using more traditional painting techniques. Stained glass is created when an artist cuts glass to a particular shape and adheres each piece to one another using a metal, called leading. Traditionally, stained glass has been associated with churches and other religious sites, typically depicting figures or scenes of importance.

Glass painting looks like stained glass, but the techniques are closer to painting with acrylics or other paints.

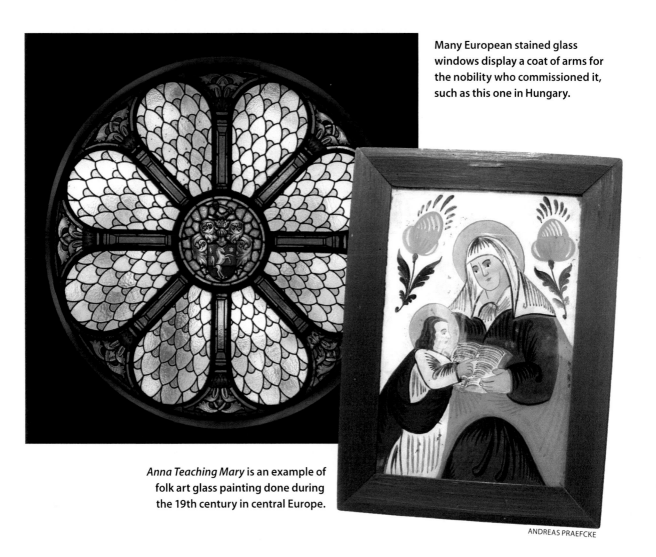

Many European stained glass windows display a coat of arms for the nobility who commissioned it, such as this one in Hungary.

Anna Teaching Mary is an example of folk art glass painting done during the 19th century in central Europe.

ANDREAS PRAEFCKE

There are many ways to color glass. It's been done since the days of ancient Egypt and Rome, though this typically involved mixing the glass with a pigment to turn the entire piece into one color. Stained glass built from this technique, evolving into intricate displays, does include painting directly on the glass. However, what separates this from the glass painting discussed in this book is that these pigments are then fired and fused to the glass. The most common of these techniques is called enameled glass.

This method of painting on glass is much more challenging and much less accessible to most people because it requires special paints and access to a glass kiln. But this long history can serve as an inspiration for your own work.

Whether you are a hobbyist or experienced artist, glass painting is accessible at home using a simple kit. Following this book, you can quickly and easily learn techniques that result in amazing glass masterpieces.

Gallery

Glass painting has had a surge in popularity in recent years, which means people around the world are experimenting and creating amazing pieces. Use this gallery as a source of inspiration for future projects. So much can be done with glass painting!

Nilima Mistry

YouTube: @CreativeArt_Nilima • Website: creativearthome.com

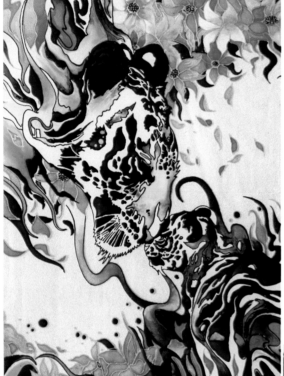

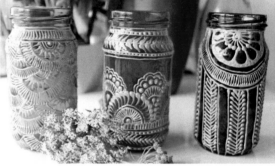

Decorative Mason Jars

I did simple mehndi designs on mason jars to make them decorative, which now I use as a decor piece, tea candle holder, and sometimes flower vase. This is a great way to recycle and reuse things.

Tigress and Cub Glass Painting

My favorite glass painting is of a tigress and cub. The mother tiger died in a forest fire but lives in baby cub's memories as his guiding spirit.

Lantern & Fishbowl

These two projects are the best use of glass colors. When we light the lantern and fishbowl using fairy lights, it looks magical. Beautiful colors coming out of lantern improve the ambiance and mood.

Mariia Prysiuda

Instagram: @my_art_workspace • Etsy: ArtMasha

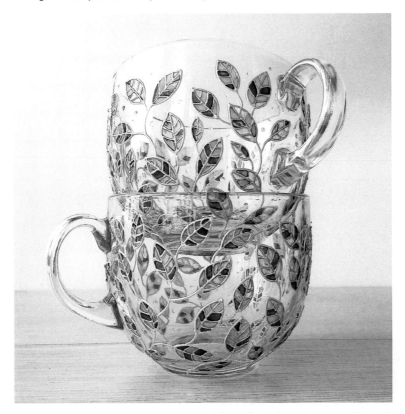

Floral Hand-Painted Green Leaves Mugs

I am inspired by nature's beauty, especially my lovely and native Ukraine. I love creativity in all its manifestations and adore the play of light on colored glass. This is all combined in glass painting.

Bugs & Beetles Hand-Painted Glass Mug

This hand-painted glass mug features multiple painted bugs (dragonflies, butterflies, beetles, ladybugs, grasshoppers, bees, damselflies, moths, ants, and June bugs), which are in chaotic order on the mug surface. Hand-painted in these vibrant colors, this design plays with the light all the time.

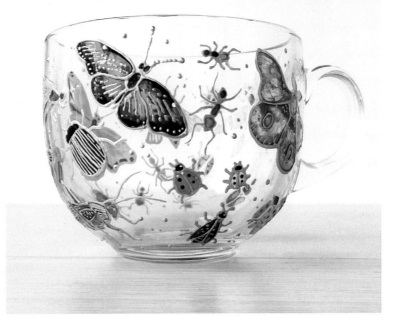

Andrea Bodnár

Instagram: @folkartfloral • Etsy: FolkArtFloral

Hi-Ball Glasses with Embroidery Design

This first design is very close to my heart because it is inspired by the Kalocsa-style floral embroidery of Hungary, which is a traditional pattern with vibrant colors. As an artist born in Hungary but now living in the UK, I wanted to honor my heritage with this series.

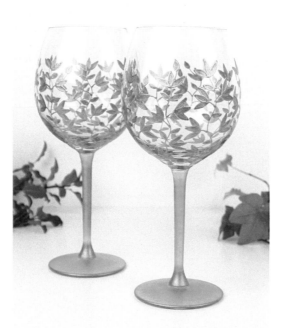

Gold Foliage Wine Glasses

This is a simple gold leaf design on wine glasses, and it is one of the favorite designs among my customers due to its elegance and simplicity.

Paria Joys

TikTok: @pariajoys • Etsy: Pariajoys

Four Seasons Suncatchers

These are my best-selling items. The idea behind it came from my love of both mandala art and nature, as well as the emotional bond between seasons and people.

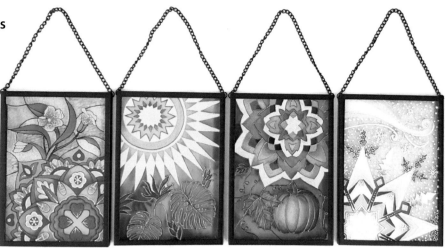

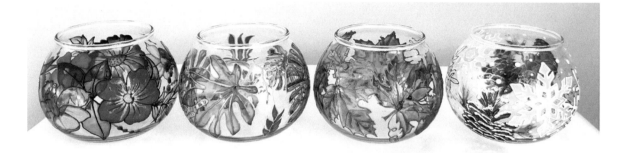

Four Seasons Tealight Holders

This set's design is inspired by features of the four seasons. With the dance of a tiny flame, they reflect the pleasing colors of nature.

Painted Mirrors

In this project I free-hand painted patterns and designs, using glass liners, transparent colors, and heavy-gel medium for creating some textures.

Anna Leleko

Etsy: ArtGlassPictures
Facebook: Anna Leleko

Snowflake Ornament

In my childhood, there were colored sugar sweets called "Montpensier." The stained glass window reminds me of these colored pieces of sugar. A painted glass picture fills a room or any other room with color and warmth. They bring joy and make you smile. For me, they carry some kind of fairy-tale magic from childhood.

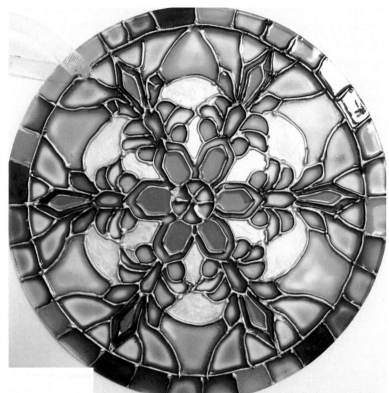

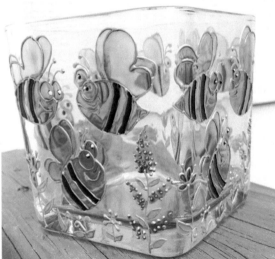

Bees Candle Holder

I started drawing 16 years ago when I was at home with my newborn son. My first paints were children's kits for painting on glass. I painted all the glass objects in my apartment. After that, I purchased professional paints and liners for glass.

Coral Glass Painting

Drawing on glass is a kind of meditation for me. The creative process, this is my world where I relax and unwind.

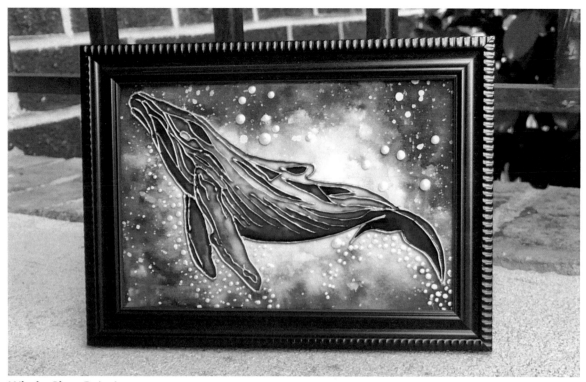

Whale Glass Painting

I also create postcards on glass. Not every picture can fit into the interior, and here you can give a postcard painted on glass. A letter or postcard is often put away in a closet, but this one can be put on a shelf and it will remind you of a joyful event and the person who gave it, which brings people joy and positive emotions.

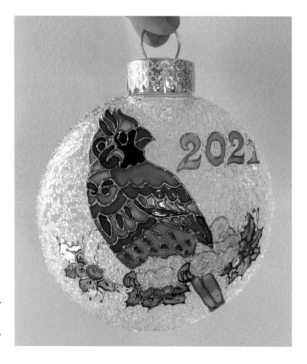

Cardinal Christmas Ornament

I use crystal texture paste for Christmas pictures and balls. Glass objects, such as blocks, pencil holders, and candle holders, create the true magic of color and light in the night.

Getting Started

In this book, glass painting is best put into two different categories according to the shape of the object or surface:

Glass Painting on Flat Surfaces. Create a painting that can hang on a wall or sit in a frame. While you can have either side be the front, I use the traditional technique of painting "in reverse," where you work on one side and flip it over. Picture frame glass, window glass panels, and similar flat glass pieces are perfect for painting with traditional techniques.

Glass Painting on Curved Surfaces. This is where painting is done on the outer curved surface of an object, such as a glass bottle, wine glass, glass ball, glass vase, or ceramic surface, then sealed using a varnish or resin. The painted surface is considered the front of the painting. The technique for this is much the same as regular

Throughout this book, I will show you how to paint "in reverse" when working with a flat surface.

painting, though the texture of glass liners adds a unique element not found in flat surfaces.

Process

Each glass painting follows these basic steps. I'll expand on techniques and materials throughout the book.

1. Select a base.
2. Clean the surface with rubbing alcohol or glass cleaner.
3. Select a reference design or draw your own design on paper. Place the design paper behind the glass.
4. Outline the design on the glass surface using a glass liner.
5. Fill in with color according to project design. Let dry.
6. Use a varnish or resin to seal the painting.

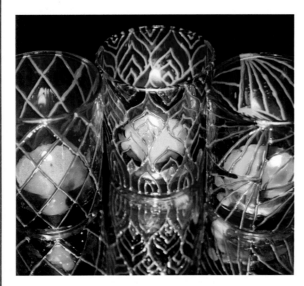

You paint on the surface of curved objects, unlike flat objects, which can create a textural element.

Materials

When starting any new craft, it's important to know what tools and materials you'll need and why. I've broken down what you'll need, why, and how it's used. Then the projects will teach you in-depth lessons on how to apply these tools and materials as you make amazing pieces.

Glass Paint

Glass paints are gel-like, ready-to-use colors that dry naturally in the air without any heat or oven use. There are a variety of options for painting glass. Many products claim they work on glass while others don't create the effect you want, so it's important to know which paints to buy. Use this as a guide to determine which paint you want.

Type. Look for paints that say they will work on glass, ideally saying "glass colors." Most paint you find in stores and online will be acrylic paints; while this is a good all-around paint, it's

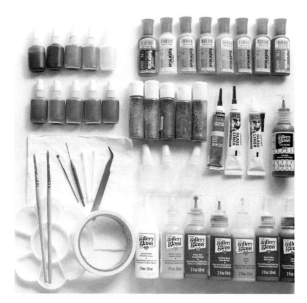

Learning the pros and cons of each brand comes with time and practice. Experiment so you can use them to their fullest capabilities.

not designed for glass. Instead, if you ever see instructions for painting on glass with acrylic, most likely they are using an acrylic enamel. Enamels are a specialty product designed for glass and other unique surfaces, which means they are much more durable.

The main choice you need to make when selecting a paint is between a water-based or solvent-based paint. Solvent-based paints are top-quality products used by professionals; therefore, they are more expensive. Water-based paints are cheaper and readily available. The main difference between these two options is how permanent they are, which will be discussed in Longevity. The other difference is that solvent-based paints take much longer to dry. I usually recommend beginners use water-based paints because they are easy to use and because there are ways to make your water-based paints last a long time.

Do not mix water- and solvent-based glass paints. Because they are made from different components, they do not mix very well. They will simply overlap or repel each other and spoil the painting, creating a milky or foggy effect.

Longevity. Tempera paints (kid's craft paint) can be used on glass, but are typically used in window displays because of how easily they can be wiped clean. Water- and solvent-based glass paint last longer and are best for projects.

Water-based paints do not last under prolonged exposure to water, such as a dishwasher, rainstorm, or under a tap. However, it's very easy to clean these pieces with a damp cloth. Then the paint should not wear off, and it will keep your art looking just like new. Solvent-based paints are essentially permanent. They should hold when washed, and are usually only affected by being scratched with a sharp object.

It should be noted that any paint can be sealed. Both varnish and epoxy resin can be used to coat your finished piece, making them last much longer.

Container. You can find paint in a bottle, tube, marker, or spray can, and all of these will add color to a piece of glass. However, markers are typically only useful for small projects while spray cans are good for coverage but not detail. All the projects in this book assume you will be using paint from a bottle or tube.

Most water-based glass paints are sold in a bottle. Not only does this give you more product to work with, but you also have more options for how to apply the paint. Glass painting can be applied using a palette and paintbrush. But you can also apply paint directly from the nozzle of a bottle, which gives you more control and reduces unused paint.

Consistency. This is where the differences between glass paint brands differ significantly. Both thick and thin paints can be used for glass painting, but they serve different techniques better.

Thin paints are what I use primarily throughout this book. They are easy to mix, which lends itself to a more painterly approach. You can use both the bottle and a paintbrush to apply paint, and you can blend colors directly on the glass surface, creating a smooth ombre within

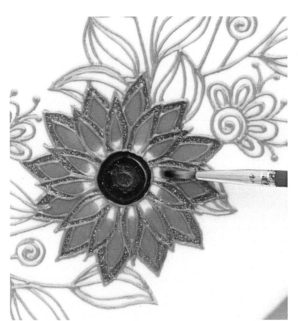

Glass colors can be painted on with any type of paintbrush.

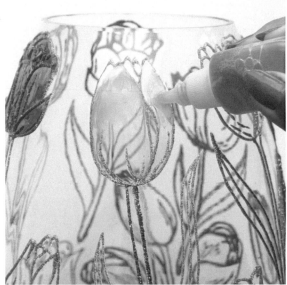

Thin paints flow easily over glass, making them easy to blend together.

the piece. Thin paints typically dry faster. The downside to thin paints is that they flow freely across glass. They must be contained to an area using glass liners (page 22); otherwise, they will flow and mix where you don't want. This also makes it hard to paint on curved surfaces, though a heat gun can be used to fix them in place. The thin paints I used in this book are Fevicryl° Glass Colour, though a similar product is DecoArt° Translucent Glass Paint™.

Thick paints do not flow as freely. While they still need a glass liner to prevent unwanted mixing, thick glass paints can be used to create small designs (such as dots, hearts, or circles) that will hold in place. Because they stay on glass better, thick paints can easily be applied to both flat and curved pieces without heat. The thick paints I used in this book are Gallery Glass®, which can also be applied to vertical surfaces. The cons for thick paint are that they are difficult to apply with a paintbrush, so you only use a bottle, and they take longer to dry. Also, the colors don't mix as well. You can use a small tool, such as a pin or toothpick, to mix paint on the surface, but the results aren't as smooth as thin paint. A similar product to Gallery Glass is the solvent-based Pebeo Vitrail. Most other thick glass paints dry more opaque.

If you have thick paints, then a number of projects in this book will need to be altered to match your supplies. See "Adjusting Step-By-Step Instructions" on page 20.

Opacity. One of the unique features of working with glass is that your paints will be translucent, allowing light to pour through your design in a pleasing way. While both thin and thick paints

Many brands of glass paints come in specialty colors, such as metallic or glitter. But you can also add glitter to your paint (see page 30).

will allow plenty of light to shine through, thick paints are generally slightly more opaque. You may want to choose your paint depending on your design and the effect you want.

There are opaque glass paints out there, but we will not be working with them in this book. However, you can also build up your thin paints to create a similar effect. Simply paint a thin layer, allow it to dry, then paint another layer.

Colors. When buying a set of thin paints, they generally come in fewer colors. This is because they are so easy to mix that you can create hundreds of colors on your own (see page 29). Thick paints are usually sold in a greater variety of colors, including metallics, glitters, and special effects (like glow-in-the-dark paint). If you prefer to not mix colors, then this could be a great option.

Adjusting Step-By-Step Instructions

Because it's so different to work with thick or thin glass paints, it is noted which I've used in each project. This lets you know whether you need to adjust the instructions given to work with your materials. Here are the main differences:

- **Glass liners.** While both thin and thick paints need glass liners (thicker paint used to enclose shapes), Gallery Glass has some unique properties to their leading that can make a huge impact on your project. Most brands rely on a steady hand to create smooth, straight lines; if you make a mistake, it's hard to remove. However, Gallery Glass solves this issue. Create lines on a piece of plastic, wait for it to dry to a tacky texture, then peel the liner off. You can then place the line in any shape needed rather than drawing directly on glass.

- **Mixing colors.** There are two ways you will encounter mixing colors in the projects ahead: creating unique colors before painting, and blending colors on the surface for a gradient effect. If using thick paint, I suggest finding a matching color rather than mixing a unique one ahead of time. However, you can still blend on the glass surface using a pin. The result may not look exactly the same, but it will still be beautiful.

- **Paintbrush and palette.** Thick paints are best applied directly from the bottle. When the instructions describe using a paintbrush and palette, instead use the "applying color with bottles" technique (page 38).

- **Checking for gaps.** Thin paints will naturally spread across the glass surface, only stopped by the glass liner. However, you need to check every nook and cranny to ensure thick paints have filled the space. After applying the paint, run a pin or similar tool through the paint to ensure an even layer that fills every gap.

- **Acrylic 3D liner.** These are handy to use for thin paints because they can create a small or thin detail without risk of having the paint run. However, thick glass paints can do this naturally. Wherever the instructions say to use an acrylic 3D liner, use your paint instead. It still needs to dry.

- **Curved surfaces.** Thin paints will run off a curved surface if heat is not applied. The benefit to thick glass paint is that this issue is eliminated. Simply skip any step that instructs you to use heat. However, you may still want to let sections dry before going too far, just to ensure your paint is not affected by handling and moving the glass.

- **Thinning paints.** You can thin your glass paints with water. However, adding water to glass paint disturbs its property and results in the paint falling apart. It only comes with experience knowing how many drops of water to add in paint to make it thin.

- **Reversing flat surfaces.** When painting on this type of surface, you have an option for which side should be the front. I prefer the traditional process of reversing the piece. This shows how the layers are painted in sequence rather than over top of each other. When using glitters, they settle on bottom of the color and are best viewed from smooth side. Another benefit is that the glass protects the painting, meaning it is does not need to be sealed. However, if you choose the texture side as your front, you may need to apply glass liner to cover any overlapping paint. You will also want to seal your work with varnish or resin.

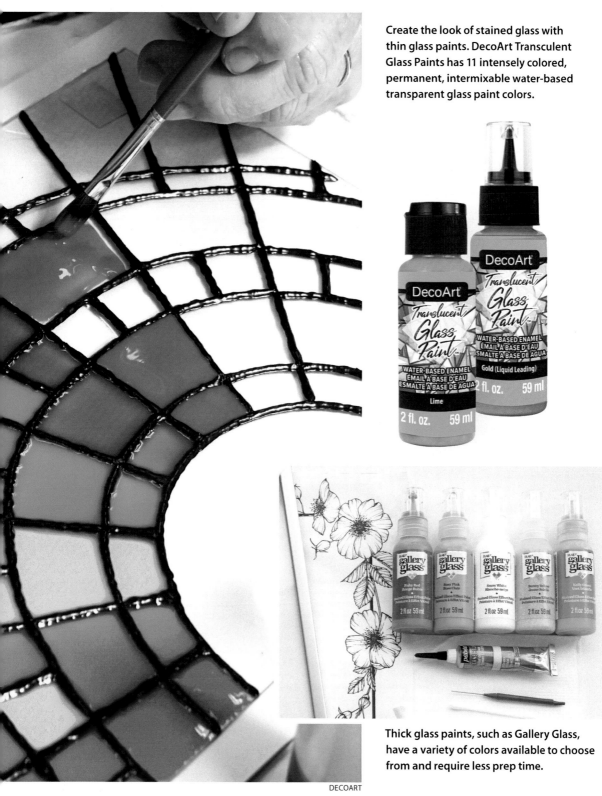

Create the look of stained glass with thin glass paints. DecoArt Transculent Glass Paints has 11 intensely colored, permanent, intermixable water-based transparent glass paint colors.

Thick glass paints, such as Gallery Glass, have a variety of colors available to choose from and require less prep time.

DECOART

Glass Liner & Glitter Liner

Liners are used to draw a design on glass. Some products call it liquid leading, which is a term carried over from stained glass. Liners come with a nozzle on the end to allow for controlled drawing and should be used like a pencil or pen. Not only do they outline the elements on a painting, but they also create a boundary for coloring. Many glass paints will mix into each other unless set apart using liners. Liners are perfect for borders because they create solid and smooth lines after drying.

Glass liners are available in different colors, including metallic and pearlescent, that can give a unique look to any painting. They are most commonly found in black or gold. Glitter liner consist of transparent glue holding fine glitters, which sparkle after drying.

Acrylic 3D Liner

Acrylic liners are colorful liners that can be used to create a small design, such as dots or small effects. Acrylic liners are like glass liners, but they cannot be used in place of glass liners; they will not contain glass paints in the same way. However, they give you control to draw on glass with paint without worrying that it will drift.

Glitter

Extra-fine glitter can be a welcome addition to any glass painting. Most commonly, it can be mixed with glass paint in a bottle or on a palette to get glitter paint, which can be used just like glass paint. Learn more about mixing paint and glitter on page 30. Glitter can also be added to paint after applying it to the glass. This technique

Glass liners create an outline that can be filled in with paint colors.

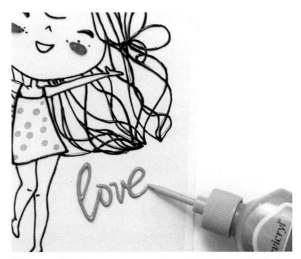

With acrylic 3D liners, create decorative elements that won't blend with glass paints.

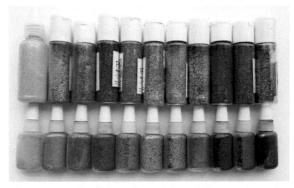

Glitter comes in all the colors of the rainbow and can tint your paint in interesting ways.

allows you to control how much glitter you want to add and makes every piece unique.

You can mix glitter with the same color of paint, such as green glitter with green paint. But there are some unique glitter-and-paint color combinations that you can play with for an iridescent effect.

Painting Surface

Glass is the most common base for glass painting, though there are multiple types. For example, pane glass and textured glass are both good options. Glass bases can also come in plenty of forms, such as vases, wine bottles, cups, teapots, picture frames, clocks, plates, etc. Once you learn how to paint on both flat and curved surfaces, you are ready to experiment with any glass piece you can find!

Acrylic sheets (also known as plexiglass) are a smart replacement for a glass base. These bases are transparent and made of clear plastic, which gives them the look and feel of glass but are lightweight and more durable. An acrylic base will not break and shatter like glass. For glass painting, acrylic bases come in different shapes and sizes like round, square, and rectangle. They also come in different thicknesses.

Overhead Projector Sheets (OHP) are another transparent base material that glass painting can be done on. This is a flexible, transparent sheet that looks like glass but is easy to fold and cut. OHP Sheet comes in different thicknesses, from 0.05–1mm; if more than 1mm thick, it is called acrylic sheet, which is stiffer when compared to OHP Sheet. OHP Sheets come in packs, so they don't need to be cleaned.

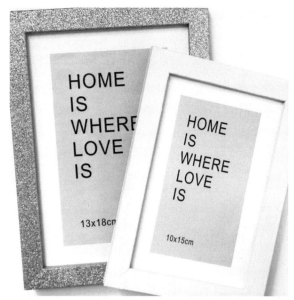

Both glass and acrylic panes are often found in picture frames at any home goods store.

OHP Sheets are a thinner version of an acrylic sheet that are flexible instead of stiff.

Backing Paper

It's important to add something to the back of flat glass to best show off the colors. Leaving a painting without a backing means that the colors will shift dramatically throughout the day, often looking dull or indistinct. What best shows off your glass painting is a shiny material that will reflect the light hitting it, "lighting up" the glass from the inside. There are several options that work here, such as aluminum foil, silver wrapping paper, glitter paper, or a similar shiny paper. Learn more on page 50.

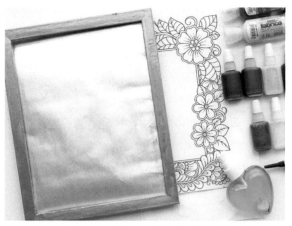

Any paper with some shine to it will reflect the light and enhance your framed glass painting.

Glass Marking Pencil

A glass marking pencil is white pencil specifically used for drawing on glass. Instead of following a pattern, you can sketch a design on your base with this pencil before drawing on top with a glass liner. If desired, you could also trace the design that is below your glass using a glass marking pencil before using the liner. This step is optional, but it can acclimate you to drawing the pattern before making it permanent with liner.

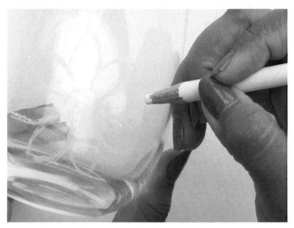

Use a glass marking pencil to create a temporary drawing that can then be cleaned away.

Small Bottle

Glass paints can be applied in one of two ways: using a paintbrush or direct application from a small bottle. Both techniques can be applied to any painting, but bottles have an added benefit. Two colors (or glitter) can be mixed in an empty bottle, creating a new color. Make sure your bottle has a nozzle at the end to place glass paint exactly where you want it. Because the bottles have screw-top caps, large amounts of paint can be made and stored for later use.

If you use thin glass paints, then it's very easy to mix colors in an empty bottle.

Paintbrush

Most glass painting in this book involves filling small areas with color, so you'll need round brushes on the smaller end. Sizes 2, 4, 6, and 8 are what I most commonly use. For glass painting, all you need are soft bristles. Any brush that you are comfortable painting with will work in this medium.

Paintbrushes can also be used for mixing colors. This can be done in a palette by combining small amounts of glass paints before placing the paint on the surface. But when you learn to combine colors on the surface, this can be done using a paintbrush. Rinse your paintbrush with water, as glass colors naturally dry in the air.

Palette

You can use a small palette with different sections to hold and mix colors. Since glass paints air-dry, pour only the quantity you need in the palette to avoid waste.

Epoxy Resin & Varnish

As glass paints are not permanent or dishwasher safe, paintings should be framed for protection. For pieces that can't be framed, it is important to protect your paint using varnish or a clear coat of resin. Both options will seal your work, so choose the method you prefer. I will use resin for the three projects where this is applicable.

Varnish is a simple way to seal your work. Simply pour a small amount of this liquid into a palette or similar surface, then paint it on your glass with a brush.

Resin is a more complex process. **Epoxy resin** comes in two parts, a resin and a hardener, that

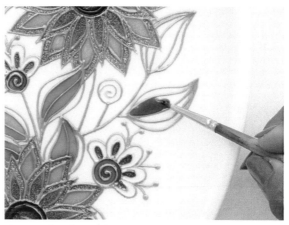

If you're familiar with painting, then using a paintbrush might be your preferred method for applying color.

Mix paint colors and glitters easily in a palette, though I recommend starting with small amounts.

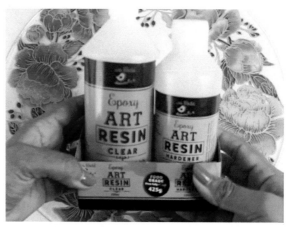

Epoxy resin typically comes in a two-part set that you need to mix when ready to use with your work.

are combined. This chemical reaction produces heat. For approximately 30 minutes, you'll have a liquid that can be poured over the glass surface to create a solid seal.

Resin Tool Set

Whenever working with resin, work in a well-ventilated room or one with open windows and doors. Always bring the following items:

- **Mixing or measuring cups** are used to combine both parts of the epoxy resin. Some products are measured in volume, which would require the measurements on the side.
- **Popsicle sticks** or **spatula** are used to mix your resin as well as spread it in an even layer. Popsicle sticks should be thrown away after each project.
- A **mask** or **respirator** is essential when working with resins, as inhaling the particulates is extremely hazardous to your health. You might also want to wear it when sanding cured resin to avoid getting the dust in your lungs.
- **Gloves** protect your skin from coming into contact with a hot chemical.
- **Protective mat or table covering** will protect your work area from the heat of resin. Cheap mats or kraft brown paper are good options. If any resin spills, you can easily throw this surface away.
- A **digital scale** will ensure you pour equal amounts of resin and hardener.
- A **handheld torch** or **heat gun** is used to pop the bubbles that form in the resin. Always be careful when working with flame.

Safety Note: Always use protective gear while mixing and handling resins. Some of the images throughout this book were staged without some pieces of gear to clearly show hand and tool positions. Always follow all safety precautions and the manufacturer's directions on the products you use.

Resin Tint & Powdered Pigment

This liquid or powder can be added to resin to change the color. While in most cases you will want clear resin on the front of your piece, the back of the glass could also have resin applied. Adding a shiny white to the resin can create a background, similar to backing paper, that will reflect light and enhance your painting.

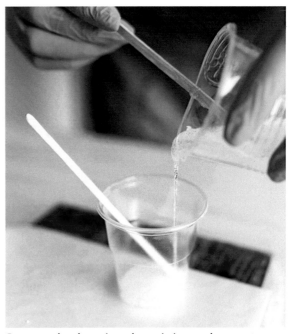

Pour your hardener into the resin in equal amounts, then combine with a popsicle stick.

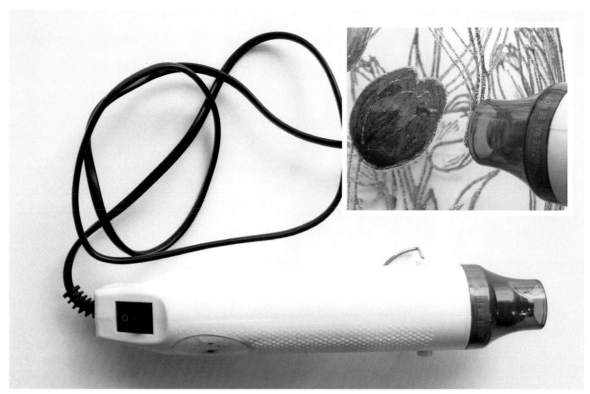

Thin paints will run on a curved surface unless secured with heat; a heat gun is the perfect handheld tool for the job.

Heat Gun

This is an electronic machine that blows hot air, similar to a hair dryer. However, its narrow tube and high heat make it perfect for art purposes. A heat gun is essential when painting with thin paints on curved surfaces and vertical glass bases. It is used to heat the glass base before painting, so the color dries quickly without flowing, as well as after painting, so the color is locked into place.

Whether you are heating up the glass surface, setting the glass paint, or popping bubbles in resin, make sure you hold the heat gun approximately 4" (10.2cm) away from the surface.

Transfer Paper

When painting on an opaque base, such as ceramic or mirror, an extra step is required to transfer the design directly onto the surface. **Carbon paper** is a sheet of thin paper with ink infused on one side. After placing it between the pattern paper and the base, you can trace the design, and the ink will transfer from the carbon paper to the surface. You can use a ballpoint pen to press the ink onto the surface, but I like using an **embossing tool** because it creates consistent lines. From here, you will trace with a glass liner.

Carbon paper will leave a mark on the surface for long enough to complete your glass painting. You can easily remove it later.

Other Equipment/Tools

Other than glass paints and liners, these are some basic supplies I use for every project:

- A **pin and cotton swab** can easily shift and remove bubbles from the paint.
- **Glass cleaner** should be used to clean your base before painting to remove dust and oils left by your fingers. You can also use **rubbing alcohol** to clean the glass.
- A **cotton cloth, napkin, or paper towel** can be used to clean excess paint and wipe down your surface.
- Use **tape** to secure the sides of the pattern to the base.
- **Scissors** can be used to cut your pattern paper and transfer paper.

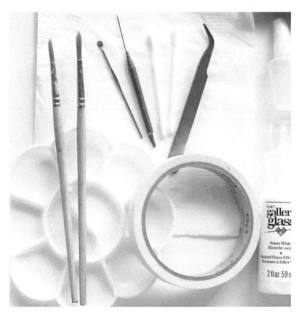

Clockwise from top left: Paintbrushes, spoon for glitter, pin on makeshift extender, cotton swabs, pick for spreading paint, paper towels, masking tape, palette.

Glass Paint Mixing Chart

Glass paints are translucent coloring mediums meant to be used on a transparent base. This is different than acrylic, oil, or watercolor paints as they are used on paper or canvas, which are opaque. Properties of glass paints highly differ from other coloring mediums because you do not mix any soluble, like water or oil, while painting. The color-mixing chart is different from a color theory chart, so it's important to follow these color combinations to get the color you want.

Here I am listing some of the most common color combinations I do for glass painting. Each project will list the colors I used, some of which will be paint combinations listed here, so it's important to look at the names to know if it's an original color or a mix. Colors differ across brands because they use different concentrations of pigments. I'm using Fevicryl paints as an example, but you'll need to test color mixing with the specific product you're using.

You can mix two or three different colors together either in a small empty bottle or in a palette using a brush. Use equal parts of each color unless there is a number listed in the recipe.

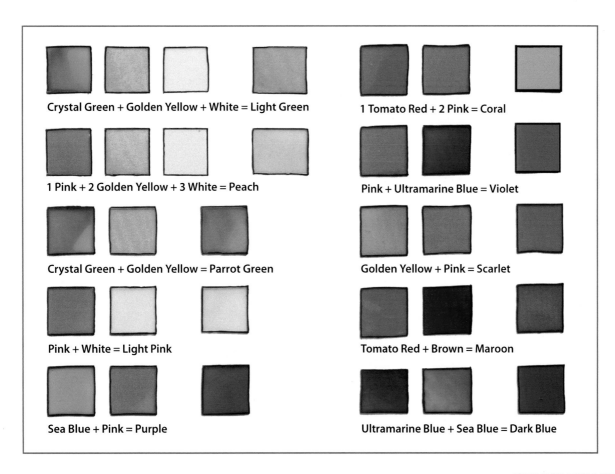

Crystal Green + Golden Yellow + White = Light Green

1 Pink + 2 Golden Yellow + 3 White = Peach

Crystal Green + Golden Yellow = Parrot Green

Pink + White = Light Pink

Sea Blue + Pink = Purple

1 Tomato Red + 2 Pink = Coral

Pink + Ultramarine Blue = Violet

Golden Yellow + Pink = Scarlet

Tomato Red + Brown = Maroon

Ultramarine Blue + Sea Blue = Dark Blue

Glitter Glass Paint Mixing

Glitter glass paints are colors that contain fine glitter. Similar to regular glass paints, glitter paints can be made by combining glitter and paint in a small bottle or container. Mixing the same color or a contrasting color creates a varied palette. There are two different ratios for mixing glitters and glass paints that gives two different looks: Glittering Opaque and Sparkling Semitransparent.

Glittering Opaque

Use a 1:3 ratio of glitter and glass paint to create a color that is full of shimmer and looks like glitter is flowing while painting. When this dries, the colored base will turn opaque.

Page 31 shows an example of mixing same-color glitter with glass paint in a 1:3 ratio.

Sparkling Semitransparent

Use a 1:8 ratio of glitter and glass paint to create a different effect. Whether the paint contains the same or contrasting glitter color, it will not be very visible at first. But when the paint dries, the base remains semitransparent, and a beautiful sparkling color is seen when the light reflects or passes through it.

Glitter will come to life in the sun, which can be a great accent or make a whole painting magical!

Important notes:

- Glitter glass paint should be freshly made each time before using.
- Mix in small quantities only.
- Do not mix glitters in solvent-based glass paint.
- Use extra-fine glitter for mixing.

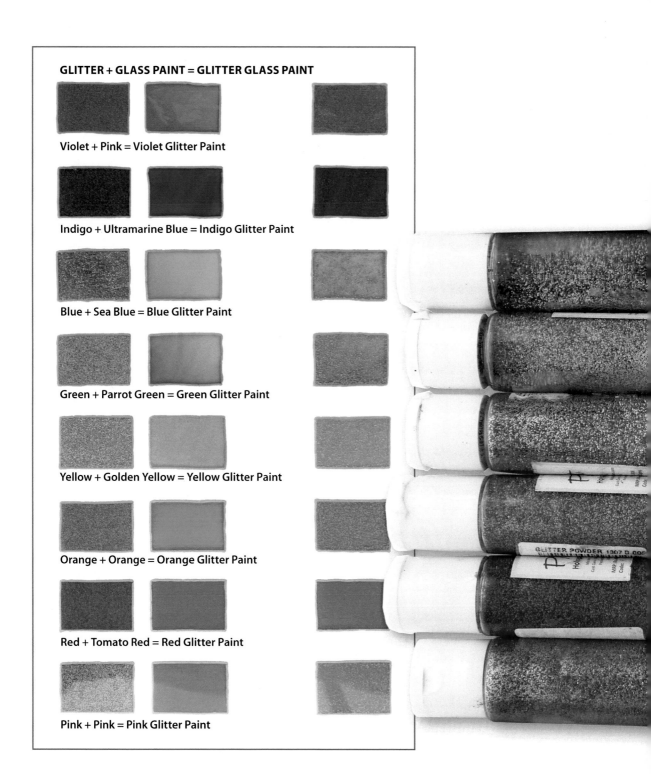

GLITTER + GLASS PAINT = GLITTER GLASS PAINT

Violet + Pink = Violet Glitter Paint

Indigo + Ultramarine Blue = Indigo Glitter Paint

Blue + Sea Blue = Blue Glitter Paint

Green + Parrot Green = Green Glitter Paint

Yellow + Golden Yellow = Yellow Glitter Paint

Orange + Orange = Orange Glitter Paint

Red + Tomato Red = Red Glitter Paint

Pink + Pink = Pink Glitter Paint

Projects

The following projects are not only gorgeous pieces that you'll want to keep in your home or give as gifts, but also are the perfect introduction for learning how to paint glass. Each project increases in difficulty, teaching new skills and building on ones you've learned. I have provided the exact size of my base and the colors I used, but that doesn't mean you have to do the same. Glass painting is great for customizing everyday objects to your tastes, so feel free to mix up the colors, sizes, and glitters. Most of all, have fun!

NOTE: Each project lists the consistency of the paint that I used (thick or thin). If you are using a different product, then you will need to adjust the steps slightly to achieve a similar result. See page 20 for more information.

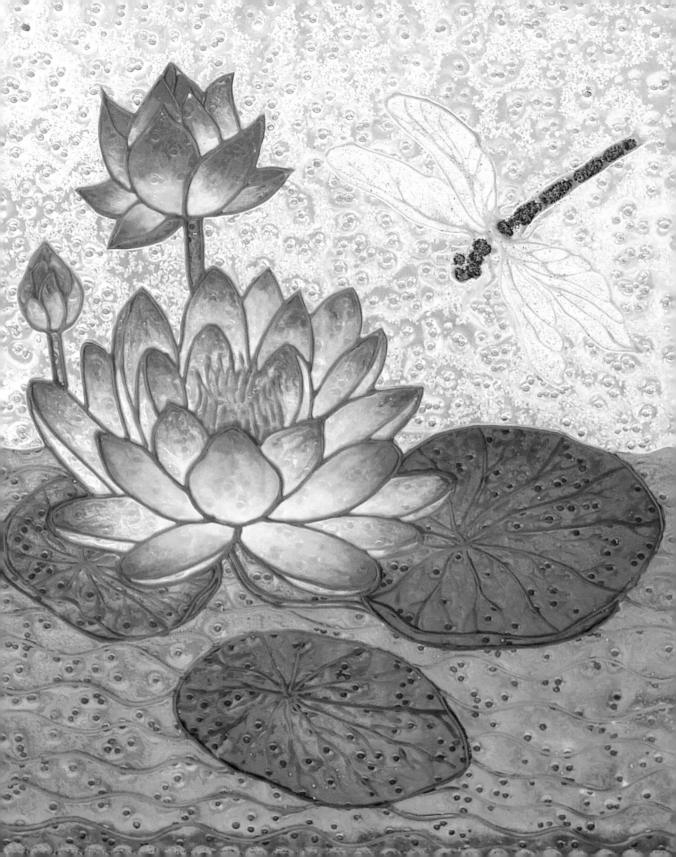

Girl in Love

DIFFICULTY: EASY

Learn a new, simple technique!

Learn how to use a glass liner in this simple project. It's great for beginners because it uses only a few materials, colors, and techniques. Using a glass liner for the first time on a smooth surface like glass can be a little tricky. With some practice, you will learn the skill to make smooth and fine lines that will make a piece look precise, neat, and beautiful. This project uses thin paints.

Materials Required:

- 4" x 6" (10 x 15cm) picture frame
- Glass paint:
 - Tomato Red
- Glass liner:
 - Black
- Acrylic 3D liner:
 - Pink
- Pattern (page 118)
- Tape
- Glass cleaner
- Cotton cloth, tissue, or napkin
- Cotton swab and pin
- Paper, aluminum foil, or other backing material

Popping Bubbles

Whenever you work with glass paints, eventually air will get into your paints and create bubbles. If left as is, the bubbles will dry in the paint and remain forever. Do not shake your bottle before using or this will introduce bubbles. To remove any bubbles, your paint must be fresh. Use a pin to pop them and smooth out your paint. A cotton swab can be used to push bubbles to the edge of your glass liner; this sometimes eliminates them, but you can also use a pin to discreetly remove the bubble without disturbing the paint.

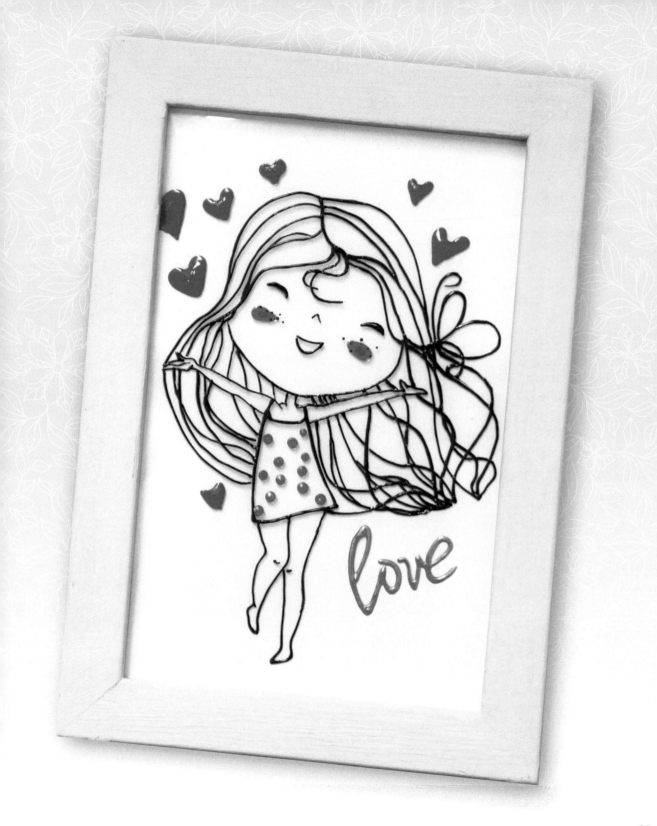

Instructions

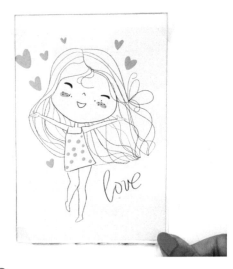

1 **Separate the glass from the picture frame by unlatching the locking clips.** Clean the base using glass cleaner and a cotton cloth. You can either draw or print the pattern at the same or smaller size than the glass base.

2 **Place the glass pane on the pattern exactly where you want the design to be.** I left a little extra room at the top to center the image. Secure both using tape.

3 **Draw on the base using Black glass liner.** Use the liner just like a pencil, tracing the lines of the pattern below. Select one element at a time, such as the hair, dress, or legs, and outline part by part. Let it dry completely for 12 hours.

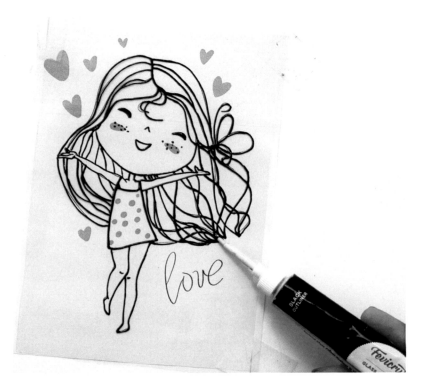

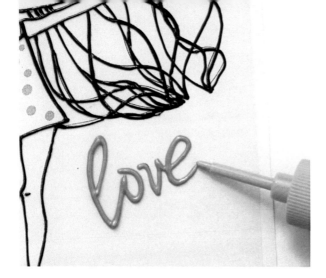

4 **Write "love" and create pink dots on the dress.** Use acrylic liner for words, dots, and small designs other than the main lines. If you want the smooth side of this painting to be the front, omit drawing "love," as it will be backward. Once the lining is complete, let it dry completely for 12–24 hours. Remove the tape and place the base on plain white paper on a horizontal surface.

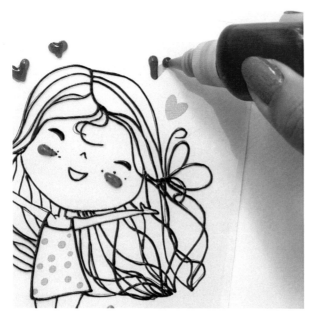

5 **Fill in the hearts using Tomato Red glass paint.** Place a drop at the top and drag it down to the point; place the next drop and connect it at the bottom to make a heart shape. Repeat to make many hearts. To create the blush, place a drop on each cheek and drag to the side.

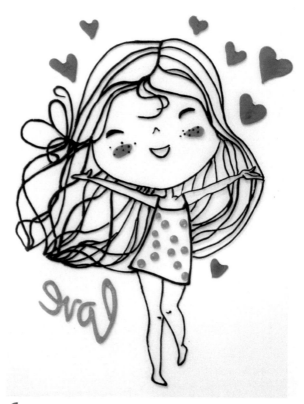

6 **Once the painting is complete, let it dry for 24 hours.** Keep the painted side as the front since the writing would be inverted otherwise. Reassemble the picture frame. Use a white sheet of paper for the background of the glass painting.

Stained Glass Frame

DIFFICULTY: EASY

Try another picture frame design!

Create an elegant photo frame with a bold, geometric design meant to resemble stained glass. These simple shapes are perfect for beginners learning how to color with glass paint bottles for the first time. Glass paints are free-flowing colors that air-dry naturally when kept out, so it is best to use them directly using a squeeze bottle or the bottle they come in. By using a squeeze bottle, it is easy to control the flow of color by squeezing the required amount of color: it creates an even spread of color, and little paint is wasted by capping the bottles. This project uses thick paints.

Materials Required:

- 5" x 7" (12.7 x 17.7cm) glass picture frame
- Glass paints:
 - Aqua
 - Snow White
 - Rosy Pink
- Glitter:
 - 5g (5ml) white
- Glass liner:
 - Black
- Pattern (page 119)
- Tape
- Glass cleaner
- Cotton cloth, tissue, or napkin
- Cotton swab and pin

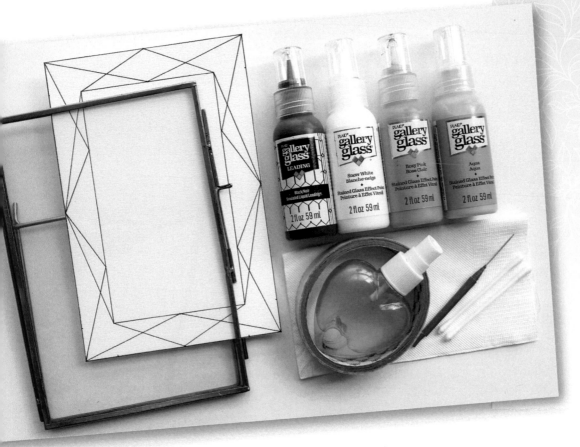

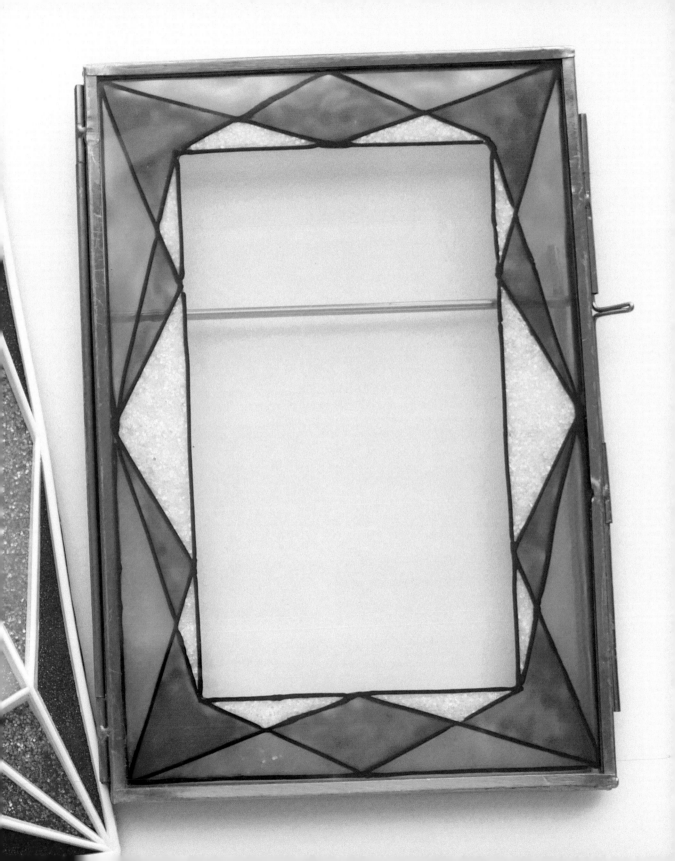

Instructions

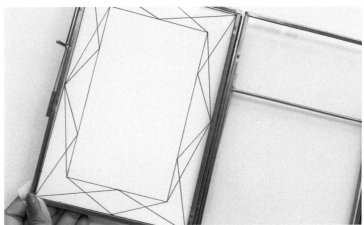

1 **Open the frame and clean the glass using glass cleaner and a cotton cloth.** Clean both sides of the frame.

2 **Draw or print the pattern at the same or smaller size than the glass.** I measured the glass base and drew a design to fit the shape. If using the pattern provided, place it in the glass frame exactly where you want the design to be. Secure using tape.

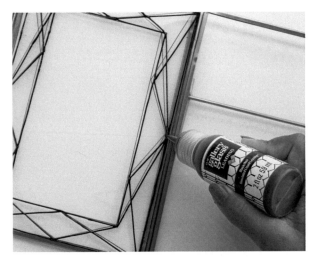

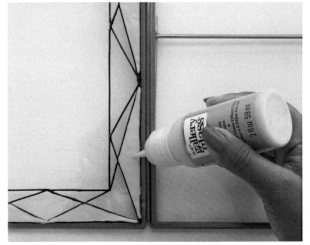

3 **Draw on the base using Black glass liner.** Use the liner just like a pencil, tracing the lines of the pattern below. Select one line at a time and draw part by part. Let it dry completely for 12–24 hours. Remove the tape and pattern paper. Place the base on a horizontal surface. If needed, insert a plain white paper under the glass to make it easier to see the lines.

4 **Fill in outer sections using Aqua glass paint directly from the bottle.** At the end with the cap, tap on the bottle so all the paint goes to the nozzle and any air goes to the top. Place the tip of the nozzle on the base and gently squeeze the bottle. Outline the shape, then fill in the middle without leaving any space.

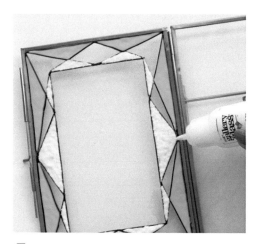

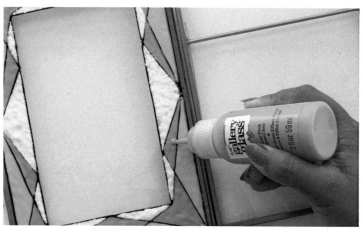

5 **Fill in inner sections using Snow White glass paint.** I created my own glitter paint by pouring white glitter into the bottle. Shake well. Paint with the bottle as you normally would. Do not cross the black lines while painting.

6 **Fill in the middle sections using Rosy Pink glass paint.** Don't leave any space while filling in the color. Once the painting is complete, let it dry for 24 hours until all colors become translucent. Close the frame.

Bright glass colors look even brighter when the sun shines through. Place your finished piece in a good spot to show off your hard work!

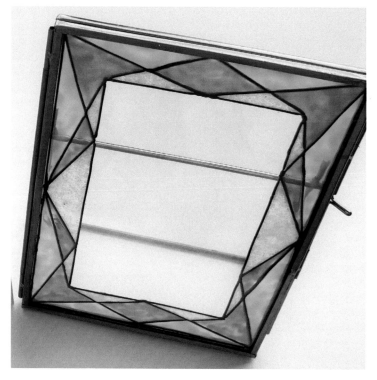

Ice Cream Cone

DIFFICULTY: EASY

Practice painting with this project!

To make this ice cream cone look more appealing, we will be using glitter glass liner instead of a solid color like black. To match the glitter liners, you can easily mix colors together using an in-the-bottle technique. Select two (or three) colors and pour them in a clean empty bottle. The amount of paint poured will decide the shade of the color. Close the bottle cap and shake the bottle well to get the new color. I consider this the most advisable technique because the bottle is closed airtight, thus the new paint color can be stored for later use. This project uses thin paints.

Materials Required:

- 4" x 6" (10 x 15cm) picture frame
- Glass paints:
 - Pink
 - White
 - Tomato Red
 - Brown
 - Crystal Green
- Glitter glass liners:
 - Rose
 - Snow
 - Red
 - Mint
 - Copper
- Small empty bottle
- Pattern (page 120)
- Tape
- Glass cleaner
- Cotton cloth, tissue, or napkin
- Cotton swab and pin
- Paper, aluminum foil, or other backing material

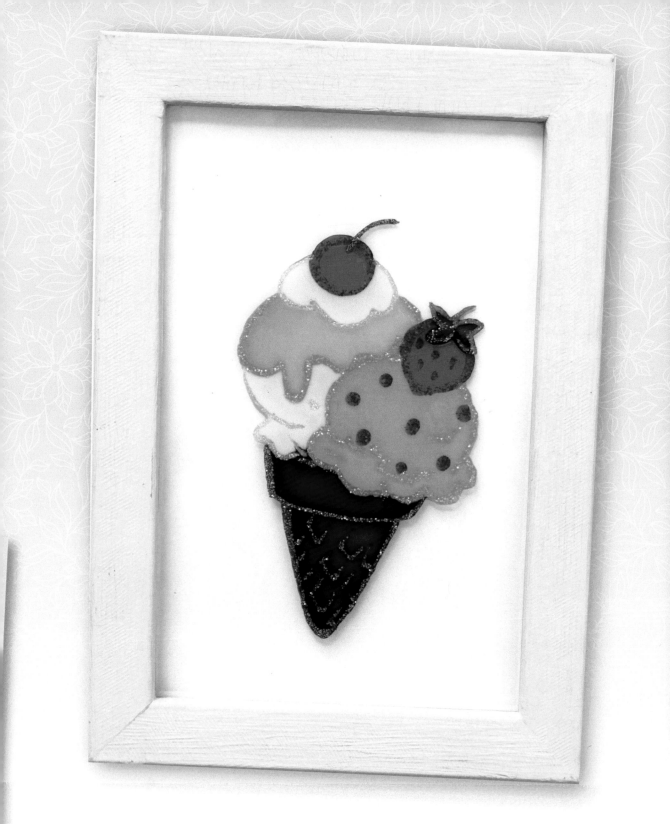

Instructions

1 Separate the glass from the picture frame by unlatching the locking clips. Clean the base using glass cleaner and a cotton cloth.

2 Place the glass pane on the pattern exactly where you want the design to be. Secure using tape.

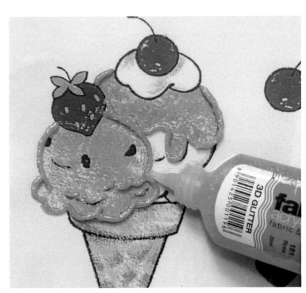

3 Draw on the base using Rose glitter liner. Select one element at a time, in this case it's the left scoop and right sauce, and outline part by part. Use the liner just like a pencil, tracing the lines of the pattern below.

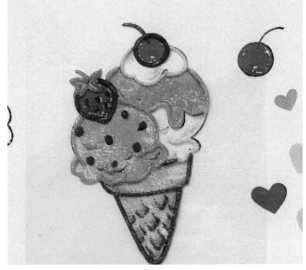

4 Continue outlining with the rest of the glitter liners. Use Snow for the right scoop and whipped cream. Use Mint for strawberry leaves. Use Copper for cherry stem and cone. Use Red for cherry, strawberry, and dots on left scoop. Once the lining is complete, let it dry completely for 12–24 hours.

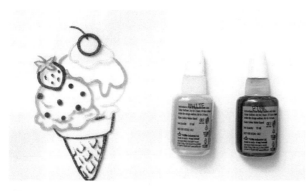

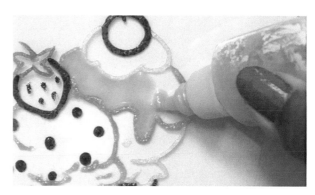

5 **Remove the tape.** Place the base on plain white paper on a horizontal surface. Mix any custom colors you need. To create Light Pink, drop equal amounts of White + Pink in an empty small bottle. Shake well. See the Glass Paint Mixing Chart (page 29) for more.

6 **Paint the pink sections.** Select one element at a time and paint part by part using the small bottles. Let a drop come out of the pointy nib of the bottle and drag the drop with a gentle press on the bottle within the section. Color patiently without crossing boundary lines of each element.

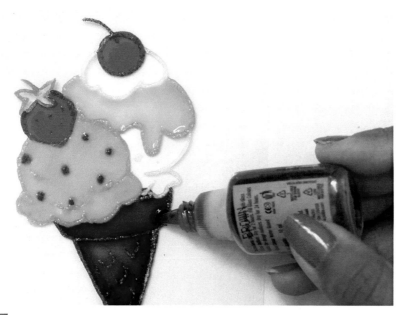

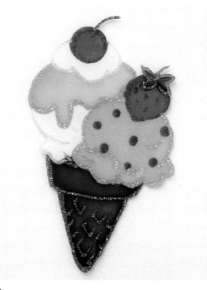

7 **In the same way, fill rest of the colors one by one.** Use Tomato Red for the strawberry and cherry. Paint the cone with Brown. Use White for the right scoop and whipped cream. Paint the strawberry leaves with Crystal Green.

8 **Let dry for 24 hours.** Flip painting over to view the smooth side, which will be the front. Reassemble the picture frame. Use a white sheet of paper for the background of the glass painting.

Selfie Couple

DIFFICULTY: EASY

Follow the video tutorial!

Materials Required:

- 5" x 7" (12.7 x 17.7cm) picture frame
- Glass paints:
 - Black
 - Brown
 - Tomato Red
 - Sea Blue
 - White
 - Pink
 - Golden Yellow
- Glass liner:
 - Black
- Size 2, 4, 6, 8 paintbrushes
- Palette
- Pattern (page 121)
- Tape
- Glass cleaner
- Cotton cloth, tissue, or napkin
- Cotton swab and pin
- Paper, aluminum foil, or other backing material

Another coloring technique is applying paint with a paintbrush. Many people find it easier using the paintbrush and palette technique since it's very similar to regular painting. The difference between painting on glass compared to painting on paper, cloth, or canvas is that glass is a smooth, nonabsorbent surface, which allows paint color to flow freely on it. Therefore, you must first create boundaries for glass paints using a glass liner. As you paint, be careful to stay within the lines. Your colors will mix or run when not contained by a glass liner. This project uses thin paints.

Instructions

1 Separate the glass from the picture frame by unlatching the locking clips. Clean the base using glass cleaner and a cotton cloth. You can either draw or print the pattern at the same or smaller size than the glass base.

2 Place the glass pane on the pattern exactly where you want the design to be. I left a little extra room at the top and bottom to center the image. Secure the pattern to the glass using tape, then tape down all four corners of the glass.

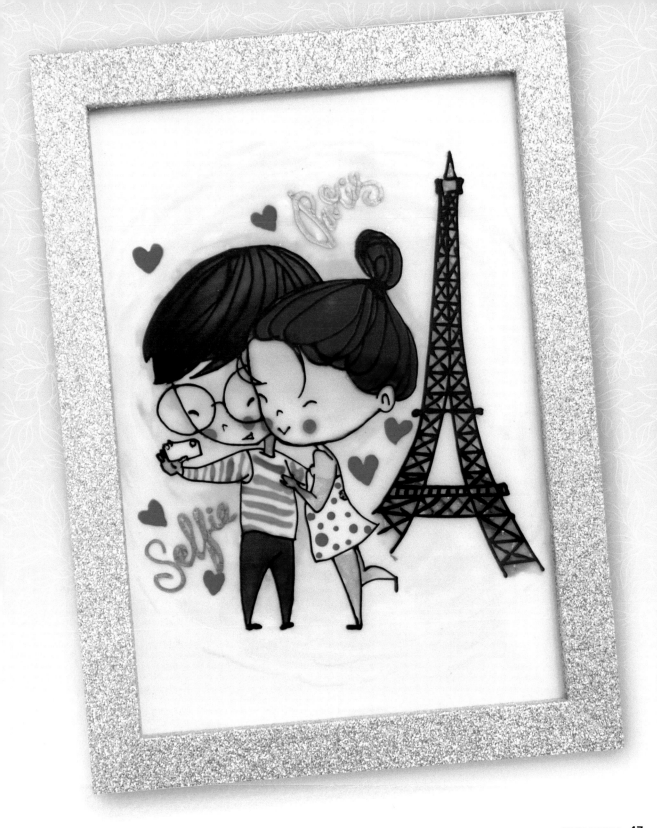

Instructions

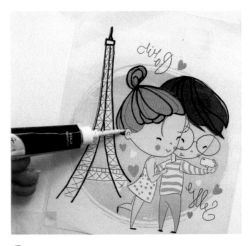

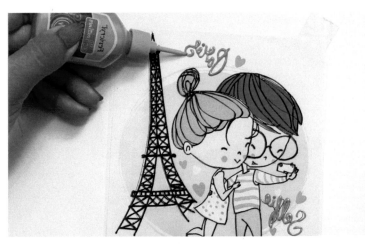

3 **Draw on the base using Black glass liner.** Use the liner just like a pencil, tracing the lines of the pattern below. Outline one element at a time. Take your time filling in the small details on the Eiffel Tower to ensure straight lines. Let it dry completely for 12 hours.

4 **Write "Paris selfie" with the pink acrylic liner.** The words are written backward so they can be read when the painting is flipped. Once the lining is complete, let it dry completely for 12–24 hours. Remove the tape and place the base on plain white paper on a horizontal surface.

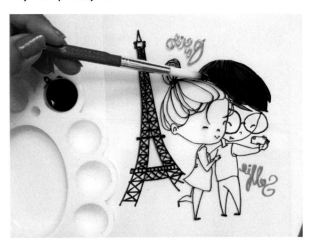

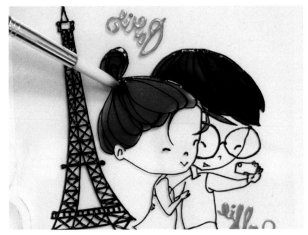

5 **Drop some Black glass paint in the palette.** Since glass paints dry in open air, pour only the required amount and close the cap of the bottle. Use a paintbrush to pick up the paint from the palette and place it on the boy's hair, painting as you would on paper or canvas. Be patient as you color to avoid crossing the boundary lines.

6 **Paint the girl's hair with Brown glass paint.** I also added a little brown to the boy's hair to give it more color. Make sure to do this after painting the girl's hair so the black does not transfer elsewhere.

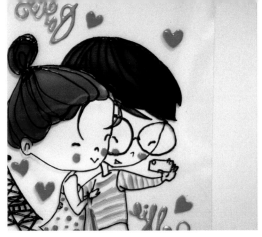

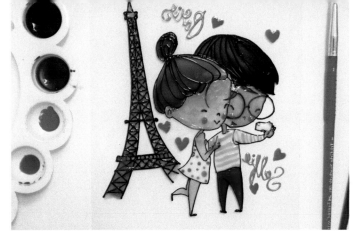

7 **Paint hearts using Tomato Red glass paint.** Add small dots on the girl's dress and on both the girl's and boy's cheeks using a small paintbrush. Then use Sea Blue to paint stripes on the boy's shirt. Let it dry for 12 hours.

8 **In the same way, fill rest of the colors one by one.** Paint the boy's pants with Brown. Use White for the girl's dress, the boy's shirt, and the boy's phone. To create custom colors, drip paint from the bottle into the palette and mix using a paintbrush. Color mixing: For their skin, make a Peach color using 1 Pink + 2 Golden Yellow + 3 White; For the Eiffel Tower, make a Gray color using 1 Black + 2 White. Let it dry for 12 hours.

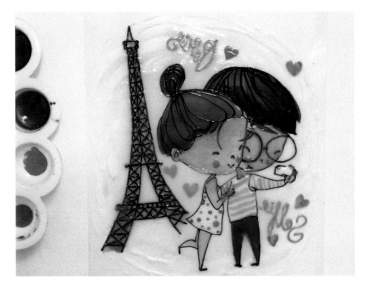

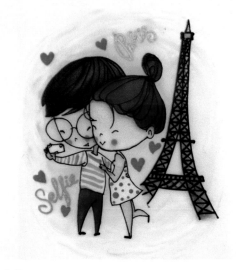

9 **Paint the circular background freehand.** Mix a Light Pink color using Pink + White glass paints. Since there are no borders, the background can be finished by leaving small lines of color in spiral shape. It's fine to slightly overlap "Paris selfie" and the hearts because they have dried. The paint will not be seen when it is reversed. However, avoid overlapping the paint in any other places.

10 **Once the painting is complete, let it dry for 24 hours.** Flip painting over to view the smooth side, which will be the front. Reassemble the picture frame. Use a white sheet of paper for the background of the glass painting.

Rose Frame

DIFFICULTY: EASY

Try another flower frame design!

Materials Required:

- 8½" x 11" (21 x 30cm) picture frame
- Glass paints:
 - Rosy Pink
 - Ruby Red
 - Kelly Green
- Glass liners:
 - Rich Gold
 - Black
- Pattern (page 122)
- Tape
- Glass cleaner
- Cotton cloth, tissue, or napkin
- Cotton swab and pin
- White glitter paper or other backing material

The background for your glass painting is an important factor that should not be overlooked. Glass paintings are semitransparent in nature and look best when placed in good light conditions. It is important for glass paintings to have a backing that emphasizes the colors used, which is best achieved with a shiny background that will reflect light.

There are different types of sheets that can be used for the background of a glass painting, such as white glitter paper and pearl-white shiny paper. But the most available and commonly used backing is aluminum foil or silver wrapping paper. Without a background paper, light will pass through a glass painting with different lighting conditions, making the painting more or less visible at different times of the day. This project uses thick paints.

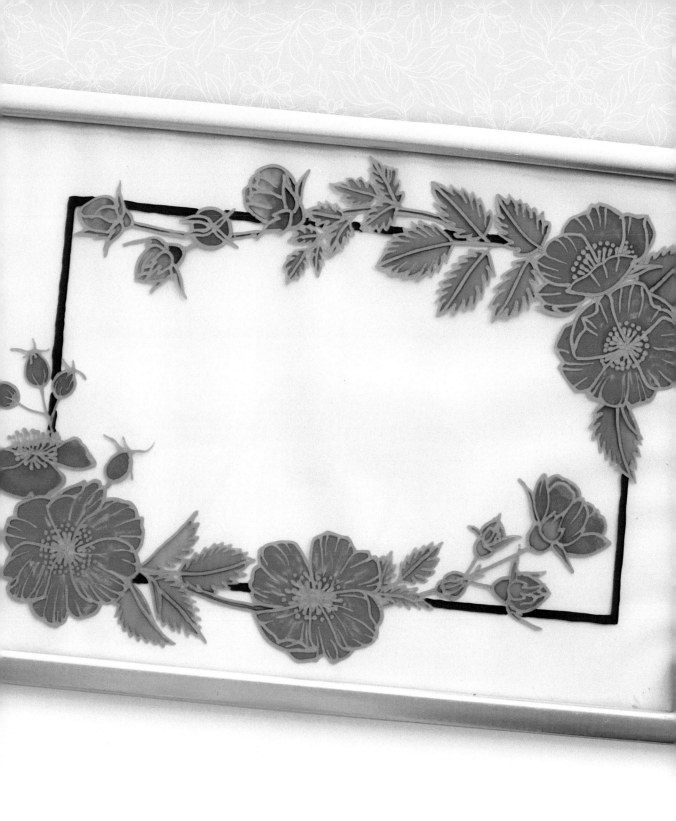

Instructions

1 **Separate the glass from the picture frame by unlatching the locking clips.** Clean the base using glass cleaner and a cotton cloth. You can either draw or print the pattern at the same or smaller size than the glass base.

2 **Place the glass pane on the pattern exactly where you want the design to be.** Secure both using tape.

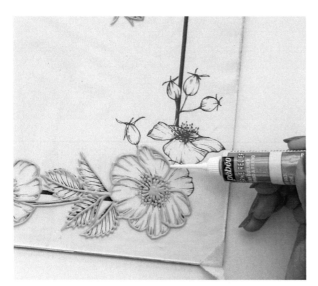

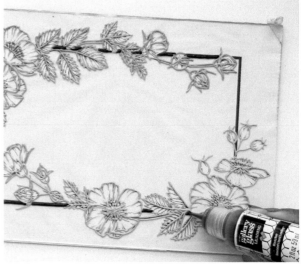

3 **Draw on the base using Rich Gold glass liner.** Use the liner just like a pencil, tracing the lines of the pattern below. Select one element at a time, such as a flower or leaf, and outline part by part. Let it dry completely for 24 hours.

4 **Trace the rectangular border using Black glass liner.** You can overlap the gold slightly, as this will not be seen when the painting is flipped. Let dry for 24 hours. Remove the tape and place the base on plain white paper on a horizontal surface.

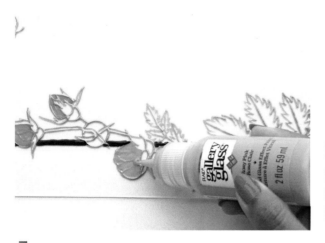

5 Fill in the flower buds using Rosy Pink glass paint.

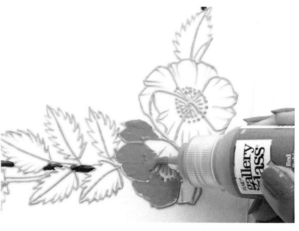

6 Fill in the rest of the flowers using Ruby Red glass paint. Let dry for 24 hours until all colors become translucent.

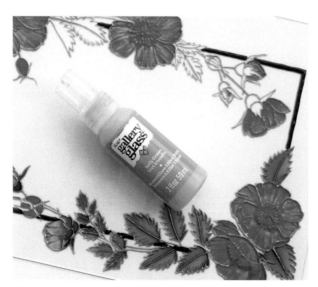

7 Fill in the leaves using Kelly Green glass paint. Let the painting dry completely for 24 hours.

8 Flip painting over to see the smooth side. This will be the front. Reassemble the picture frame. Use a sheet of white glitter paper for the background of the glass painting.

Hydrangeas

DIFFICULTY: EASY

Follow the video tutorial!

Make a beautiful painting of blue hydrangeas using a very simple color shading technique. Shading is a natural phenomenon of light that is found everywhere; the direction of the light hitting an object will create a lighter area as well as shadows. Shading the surface of a 2D drawing can give it a 3D look.

Shading can be done simply by mixing black or white with a color. In the same vein, a lighter color can be used for shading a darker color and vice versa. In this project, blue and white paints will be mixed to create a more natural flower, and green and yellow will be used for the leaves. This project uses thin paints.

Materials Required:

- 8" x 10" (20 x 25cm) picture frame
- Glass paints:
 - Sea Blue
 - White
 - Crystal Green
 - Golden Yellow
- Glitter glass liners:
 - Blue
 - Silver
 - Green
- Small empty bottle
- Pattern (page 123)
- Tape
- Glass cleaner
- Cotton cloth, tissue, or napkin
- Cotton swab and pin
- Paper, aluminum foil, or other backing material

Instructions

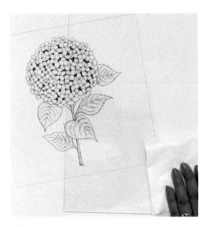

1 **Separate the glass from the picture frame by unlatching the locking clips.** Clean the base using glass cleaner and a cotton cloth. You can either draw or print the pattern at the same or smaller size than the glass base.

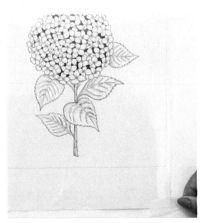

2 **Place the glass pane on the pattern exactly where you want the design to be.** Secure both using tape.

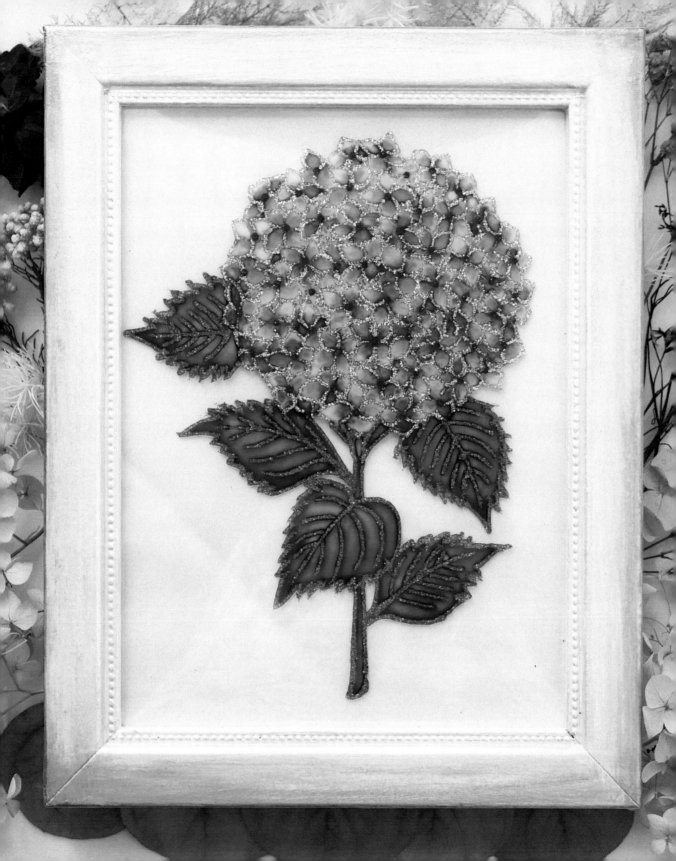

Instructions

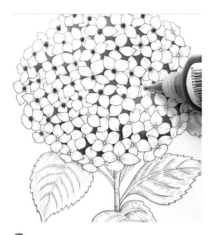

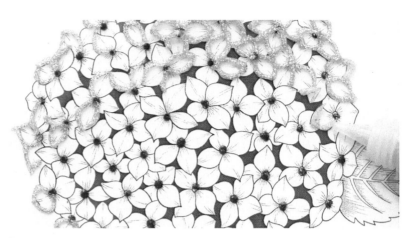

3 **Create dots with Blue glitter liner.** These will be the centers of each hydrangea flower.

4 **Draw petals with Silver glitter liner.** Use the liner just like a pencil, tracing the lines of the pattern below. I usually outline one or two petals of each flower first, then fill out the rest. Because there are so many small lines close together, I find it's easier to see which areas are the most crowded and simplify the design there if necessary.

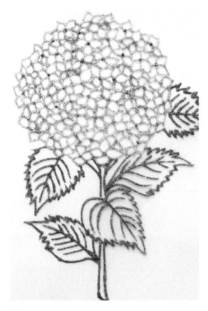

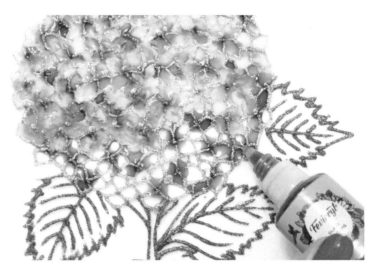

5 **Draw leaves with Green glitter liner.** Once the outline is complete, let it dry completely for 12–24 hours. Remove the tape and place the base on plain white paper on a horizontal surface.

6 **Paint the flower petals.** Pour a drop of Blue glass paint right in the center of four petals where a blue glitter dot was made. This will make the center of flower petals look blue. Then pour a drop of White in the remaining half of the petal. As the petals are quite small, colors will mix naturally and shade the flower beautifully. Color patiently without crossing the silver boundary lines of flower petals.

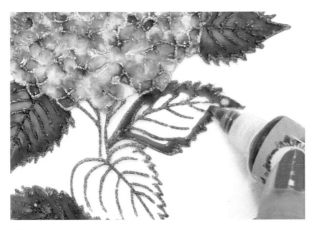

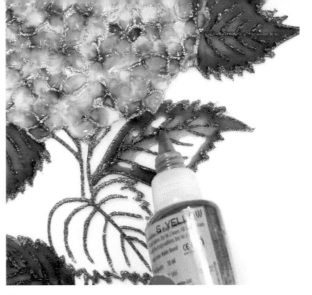

7 **Start painting the leaves with Crystal Green glass paint.** Color the outside edges of each leaf.

8 **Paint the inner leaves with Golden Yellow glass paint.** Carefully fill in along just the centerline of each leaf.

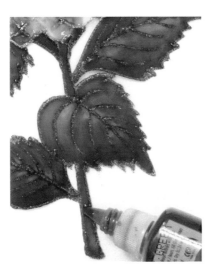

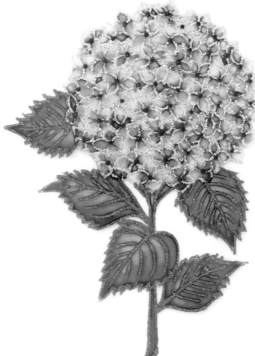

9 **Mix Parrot Green (Crystal Green + Golden Yellow).** Fill in the rest of the leaf by alternating between Parrot Green, Crystal Green, and Golden Yellow. The lighter yellow will highlight the center of each leaf. Then fill in the stem with Crystal Green.

10 **Once the painting is complete, let it dry for 24 hours.** Flip painting over to view the smooth side, which will be the front. Reassemble the picture frame. Use a white sheet of paper for the background of the glass painting.

Floral Drinking Glass

Try more drinking glass designs!

DIFFICULTY: INTERMEDIATE

In this project, you will be painting small flowers on a cylindrical glass, which can also be done on a vase or wine glass. Painting on a curved surface is different from painting on a flat surface. Every time an element is drawn with liner, you must let it dry and then do the other side. This rule is also followed while painting. You will be using a paintbrush for coloring and a heat gun for stabilizing glass paint.

Freehand drawing or painting means to draw or paint without using exact measurements or a ruler. This technique is handy when using a curved surface because you don't need to worry about using a printed reference. Instead, draw directly on the glass using a glass marking pencil and gold glass liner. Make sure to complete the drawing without spoiling the design you made first. However, if you are not comfortable freehand drawing, I've provided a pattern that you can use. This project uses thin paints.

Materials Required:

- Two 4½" (11.5cm) drinking glasses
- Glass paints:
 - Orange
 - Golden Yellow
 - Crystal Green
 - White
- Glass liner:
 - Metallic Gold
- Pattern (page 124)
- Glass marking pencil
- Size 2, 4, 6 paintbrushes
- Palette
- Heat gun
- Glass cleaner
- Cotton cloth, tissue, or napkin
- Cotton swab and pin

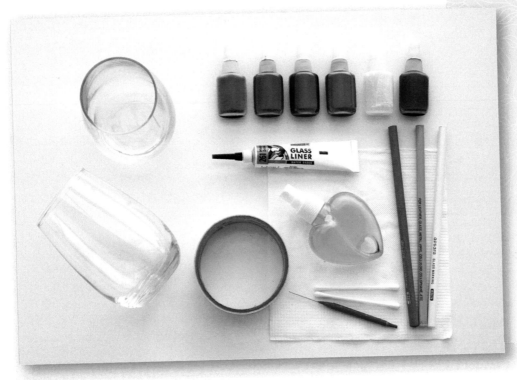

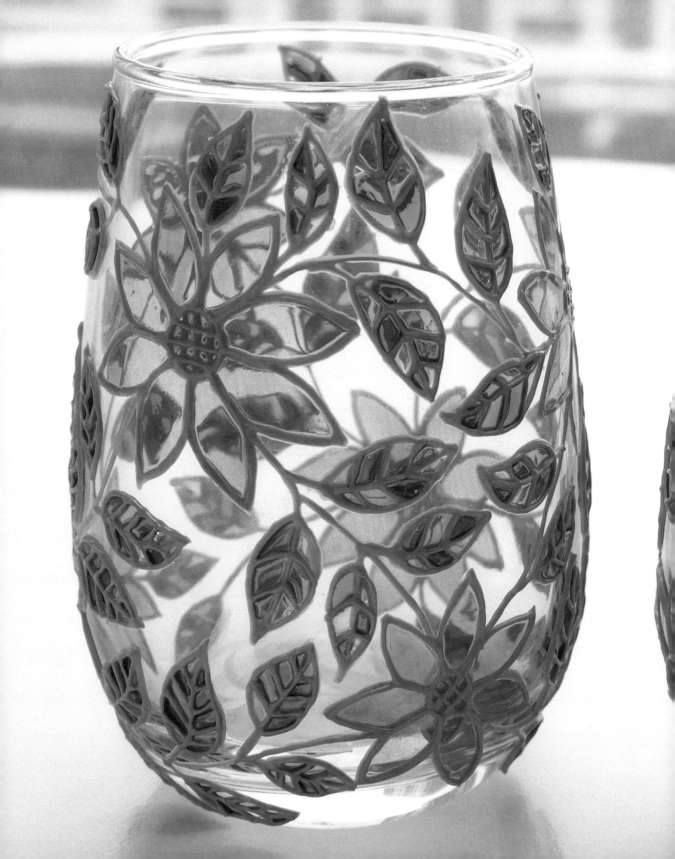

Instructions

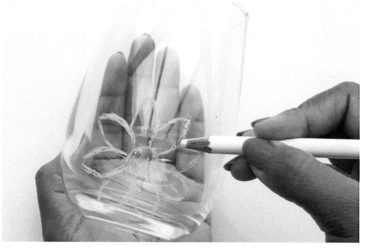

1 **Clean the glasses using glass cleaner and a cotton cloth.** This will make the surface clean and oil free.

2 **Draw flowers freehand using a glass marking pencil.** Start by making a small circle for the center. Then draw petals extending out. Hold the glass in a comfortable way that makes it easy to draw but does not disturb the previous drawing. Leave room for branches and leaves. I typically add these only with glass liner, but you can sketch these elements on at this step. If using the pattern, see page 88 for how to trace on a curved surface.

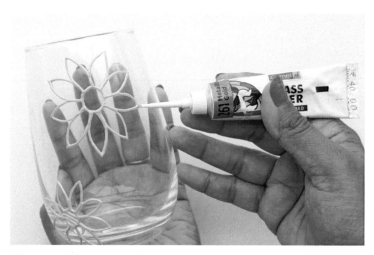

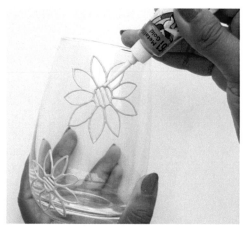

3 **Trace one flower using Metallic Gold glass liner.** Let dry completely for 2–3 hours. Prop the glass up so the drawing is as horizontal as possible. This will prevent the liner from running. Repeat for each flower. Make one at a time, drying between each flower.

4 **If desired, add detail to the flowers.** While outlining each flower, you can add lines inside the flower centers. Create diagonal lines in one direction, then repeat in the opposite diagonal.

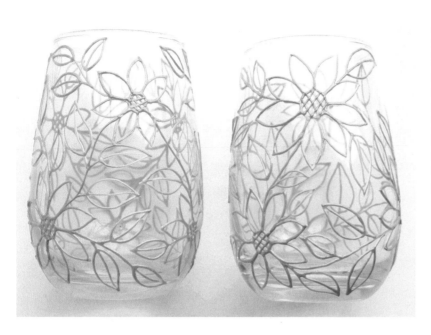

5 **Fill in the empty spaces using Metallic Gold glass liner.** Freehand draw branches connecting one flower to another. Draw the leaves extending from the branches. Because this is freehand drawing, all the flowers and leaves can be different sizes and shapes. Once the glass lining is complete, let it dry for 24 hours.

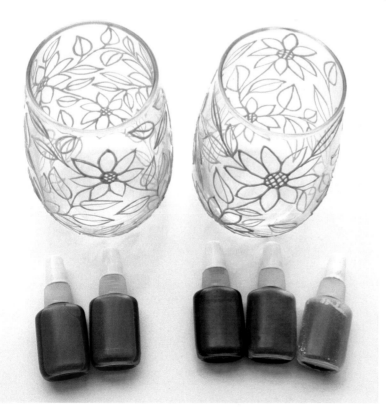

6 **Pour small amounts of glass paints in a palette.** As glass paints will air-dry, they will become rubbery if left out too long. Mix any custom colors you need. To create Light Green, drop equal amounts of Crystal Green + Golden Yellow + White in the palette. Mix with a paintbrush. You can also mix colors in a bottle and pour a small amount of paint into your palette.

NOTE: Thin glass paints are a free-flowing liquid. When placed on a cylindrical surface, using a heat gun is mandatory.

Instructions

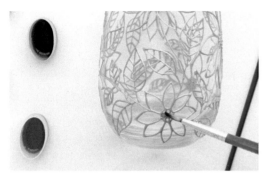

7 **Paint flower centers with Orange glass paint.** Place glass on a flat surface. Use the paintbrush to pick up a small amount of paint and place it on the glass. Color patiently without crossing the boundary line. After each center is painted, use the heat gun to stabilize the paint. Use a low heat for 30–40 seconds, keeping the heat gun approximately 4" (10cm) from glass. Do not overheat.

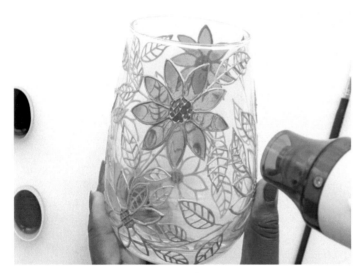

8 **Paint flower petals with Golden Yellow glass paint.** Paint one or two petals, then use the heat gun to make the colors stable. Use the same precautions as step 7. Repeat this process with all the petals of a flower, then let each flower dry naturally for an hour. Paint each flower in the same way.

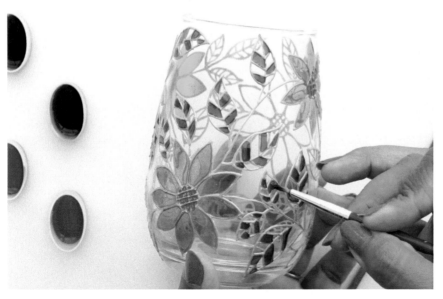

9 **Partially paint leaves with Crystal Green glass paint.** Alternate coloring leaf sections. Use the heat gun to quickly dry the paint. Each time, let one section of color dry completely, then do the next section without spoiling the first. Color patiently without crossing the glass liner.

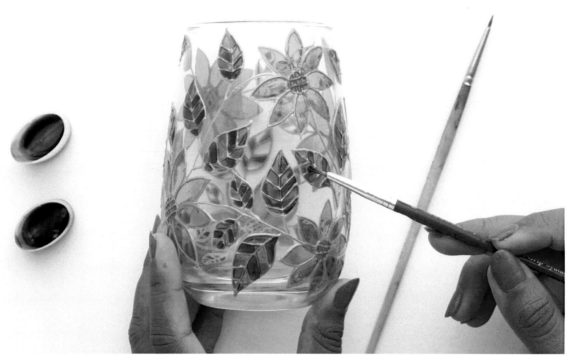

10 **Finish painting leaves with Light Green glass paint.**
Color the remaining sections and use the heat gun to dry them
quickly. Once the painting is complete, let dry for 24 hours.

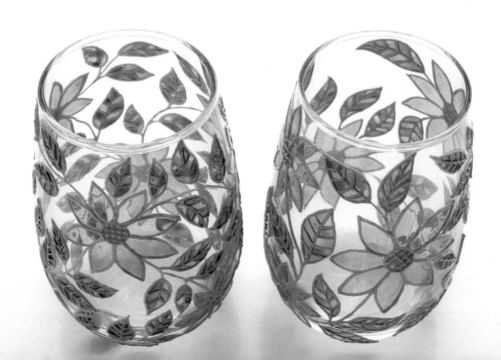

Unicorn

DIFFICULTY: INTERMEDIATE

Practice glitters with this project!

Make a shimmering and sparkling glitter glass painting of a unicorn with a rainbow tail and mane. Except for the unicorn's body, this whole piece will have you mixing different colors of glitters to make all new glittering glass paints. You will use both Glittering Opaques (one part glitter, three parts paint) and Sparkling Semitransparent (one part glitter, eight parts paint). Learn more on page 30. These paint and glitter colors will match for a bright, saturated effect.

For a base, we are using an acrylic sheet. Glass paints behave the same whether using glass or acrylic, so you don't need to adjust your techniques depending on which option you choose. Acrylic is a great choice because it is more durable as compared to glass. This project uses thin paints.

Materials Required:

- 12" x 12" (30 x 30cm) picture frame
- 12" x 12" (30 x 30cm) acrylic base
- Glass paints:
 - Black
 - Sea Blue
 - Pink
 - Tomato Red
 - White
 - Ultramarine Blue
 - Crystal Green
 - Golden Yellow
 - Orange
- Glitters:
 - Black
 - Maroon
 - Pink
 - Copper
 - White
 - Violet
 - Indigo
 - Blue
 - Green
 - Yellow
 - Orange
 - Red
- Glass liners:
 - Metallic Silver
 - Black
- Acrylic 3D liner:
 - Pink
- Glitter glass liners:
 - Silver
 - Snow
 - Light Blue
 - Light Pink
- Small empty bottles
- Pattern (page 125)
- Tape
- Cotton swab and pin
- Paper, aluminum foil, or other backing material

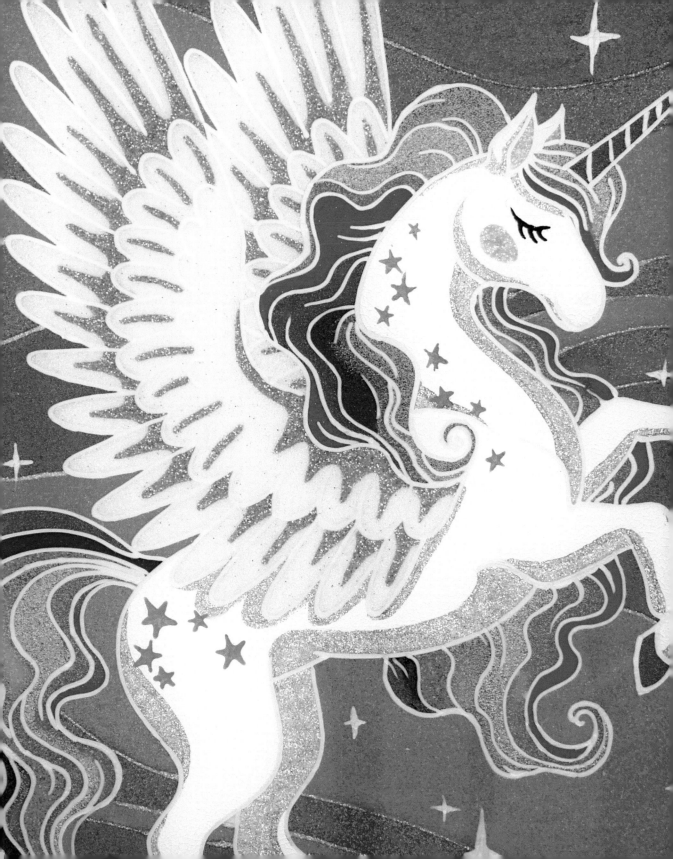

Instructions

1 **Separate the acrylic sheet from the picture frame by unlatching the locking clips.** Acrylic sheets come wrapped between protective white and brown paper; gently peel off the protective cover.

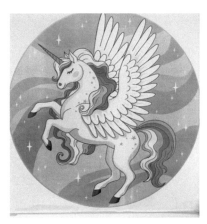

2 **Place the acrylic sheet on the pattern exactly where you want the design to be.** You can either draw or print the pattern at the same or smaller size than the base. Secure both with tape.

3 **Outline the unicorn using Metallic Silver glass liner.** Use the liner just like a pencil, tracing the lines of the pattern below. Select one element at a time, such as the tail, mane, or wings, and outline it part by part. Trace the stars surrounding the unicorn.

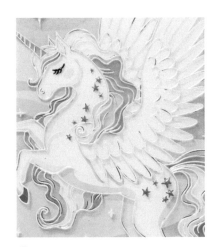

4 **Draw stars on unicorn using Pink acrylic liner.** Use Black glass liner for eyelashes. Let it dry completely for 12 hours.

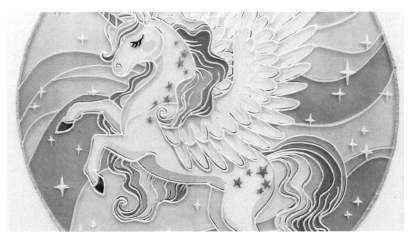

5 **Trace background lines with glitter glass liners.** Use Silver for the circle surrounding the design. Use Snow to trace the curvy lines of the night sky. Once the outlining is done, let it dry completely for 12–24 hours. Remove the tape and place the base on plain white paper on a horizontal surface.

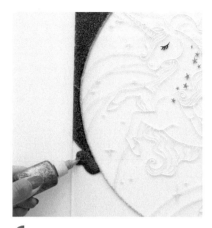

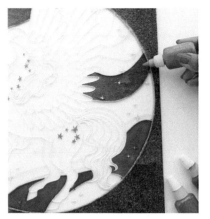

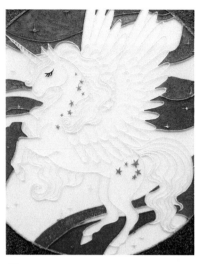

6 Create a black glitter glass paint. Mix 1 black glitter + 3 Black glass paint in a small bottle. Shake well. Using the black glitter paint, fill in the background surrounding the circle design. Be careful when approaching the edge of the base so the paint won't run off.

7 Create a purple glitter glass paint. In a small bottle, mix the custom glass paint color: Sea Blue + Pink = Purple. Shake well. In another bottle, mix 3 Purple glass paint + 1 magenta glitter = purple glitter paint. Fill in the darkest sections of the night sky. Color patiently without crossing the boundary lines.

8 Create a pink glitter glass paint. Mix 1 pink glitter + 3 Pink glass paint in a small bottle. Shake well. Fill in the medium sections of the night sky.

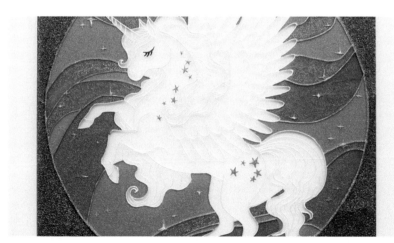

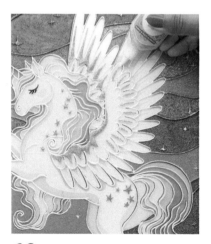

9 Create a coral glitter glass paint. In a small bottle, mix the custom glass paint color: 1 Tomato Red + 2 Pink = Coral. Shake well. In another bottle, mix 3 Coral glass paint + 1 copper glitter = coral glitter paint. Fill in the lightest sections of the night sky. After completing the background, let the painting dry for 12–24 hours.

10 Create shadows on wings using glitter liner. Place the acrylic sheet back on the pattern. Using Light Blue glitter liner, draw lines in wings with pointed edges to make it look sharp.

Instructions

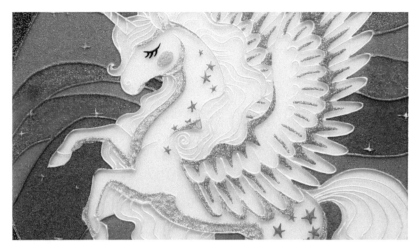

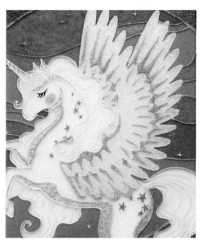

11 **In the same way, use Snow glitter liner for the shadows on the unicorn.** Then use Light Pink glitter liner for blush. Let the liners dry for 24 hours. Remove the pattern from underneath.

12 **Create a white glitter glass paint.** Mix 1 white glitter + 3 White glass paint in a small bottle. Shake well. Fill in the wings.

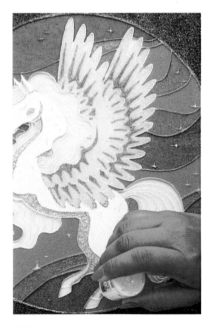

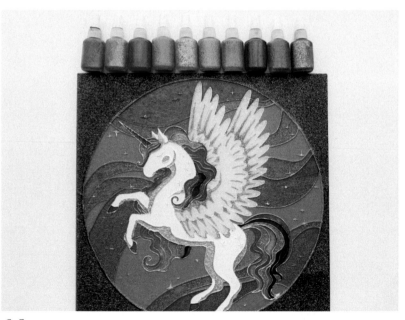

13 Paint the unicorn's body using White glass paint.

14 Paint the unicorn's mane and tail with Sparkling Semitransparents. This uses a ratio of 1:8. To create each color, follow the chart on page 30.

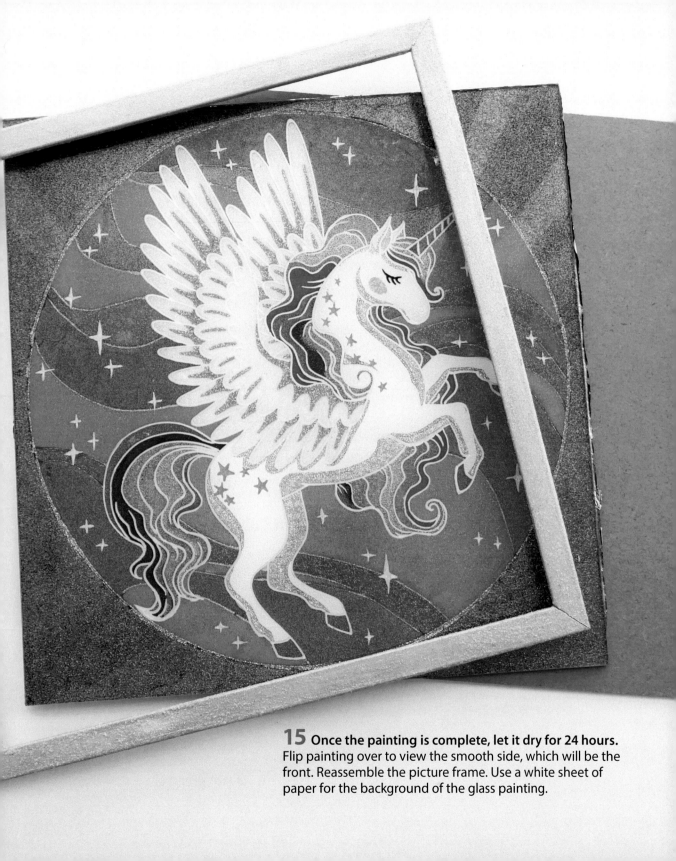

15 **Once the painting is complete, let it dry for 24 hours.**
Flip painting over to view the smooth side, which will be the
front. Reassemble the picture frame. Use a white sheet of
paper for the background of the glass painting.

Lotus on Textured Glass

Follow the video tutorial!

DIFFICULTY: INTERMEDIATE

Materials Required:

- 6" x 8" (15 x 21cm) textured glass
- Wooden sign mount
- Glass colors:
 - Golden Yellow
 - Sea Blue
 - White
 - Pink
 - Crystal Green
- Glitters:
 - White
 - Blue
- Glass liners:
 - Metallic Gold
 - Metallic Silver
- Small empty bottles
- Pattern (page 126)
- Tape
- Cotton swab and pin

For this project, you will be painting on textured glass. Textured glass has decorative patterns in it, which are created by overheating the glass on a textured surface. It is also known as patterned glass or decorative glass; they come in variety of patterns, designs, and colors, and are mostly use for interior decoration. Frosted glass, for example, is interesting for glass painting because we can't see through it though it still scatters light. This project mounts the glass on a vertical stand to get the maximum effect of the light passing through the patterned glass, creating a beautiful effect.

To create the pink gradients of the lotus petals, you will be mixing paints on the glass surface. To mix two different colors, first place the lighter color, then the darker color. If the design is very small, both colors will mix and create shading by themselves. In the case of bigger designs, like the lotus petals in this painting, use a pin or a paint brush to drag some part of the light color into the dark color or vice versa. This can then be repeated for multiple colors. This project uses thin paints.

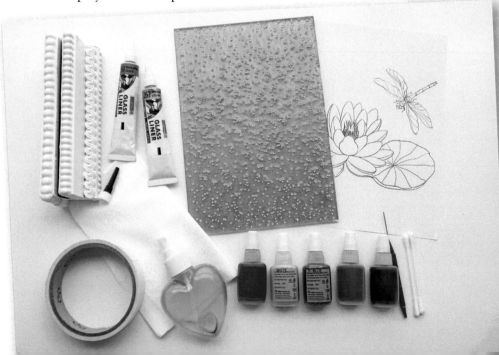

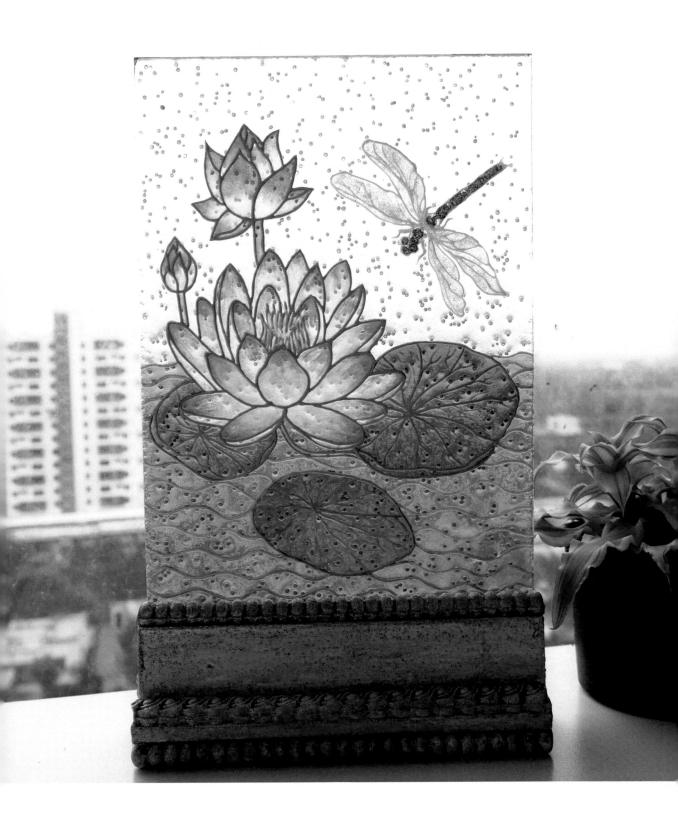

Instructions

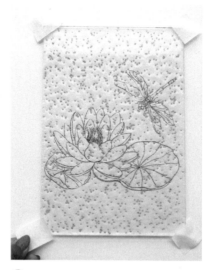

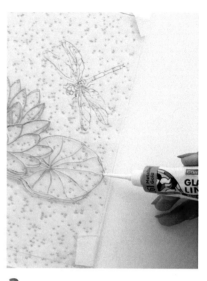

1 **Gently peel the protective cover off the textured glass.** One side of the glass has a smooth surface and the other has texture. Sometimes, the smooth surface is covered with a brown cover to protect it. There are different types of glass textures available; make sure to select a texture that complements the design.

2 **Place the glass on the pattern exactly where you want the design to be.** You can either draw or print the pattern at the same or smaller size than the base. Secure both with tape.

3 **Outline the lotuses and lily pads using Metallic Gold glass liner.** Use the liner just like a pencil, tracing the lines of the pattern below. Select one element at a time, such as the petals, and outline part by part. If desired, use a light hand to add extra lines on the lily pads to create the leaf veins. Let dry for 12 hours.

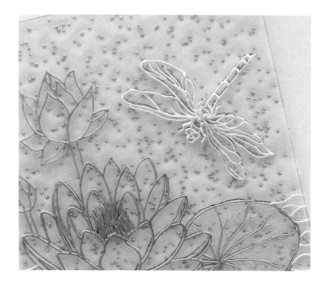

4 **Outline the dragonfly using Metallic Silver glass liner.** Release the bottom two pieces of tape. Then, freehand draw curvy lines to represent water. Make the top waterline about halfway up the lotus so it looks like it's resting on the waves. After completing the outlines, let it dry for 24 hours. Remove the tape and place the base on plain white paper on a horizontal surface.

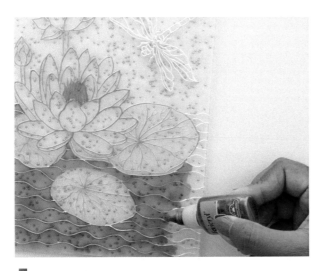

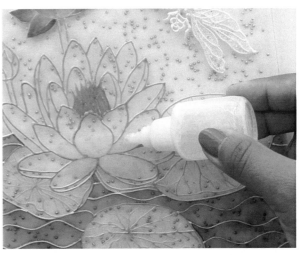

5 **Paint lotus center using Golden Yellow glass paint.** Use Sea Blue to paint the water. In an empty small bottle, mix a white Glittering Opaque (3 White glass paint + 1 white glitter). Shake well. Paint the dragonfly wings with white glitter paint.

6 **Paint the base of the lotus petals using White glass paint.** Only fill one-third to one-half of each petal, starting at the base. The rest of the petal will be filled with two pinks and then blended. Only paint two or three petals at a time.

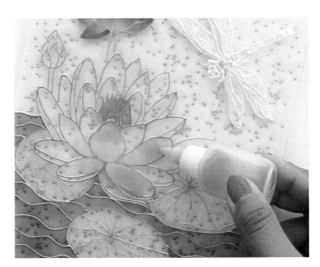

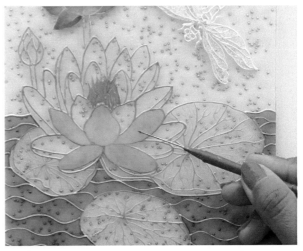

7 **Mix Light Pink glass paint (White + Pink) in an empty small bottle.** Shake well. Pour Light Pink into the lotus petals, leaving room at the tips for Pink glass paint.

8 Using a pin, mix White and Light Pink in the middle of both colors. This will create a gradient between the colors. Stir gently so paint doesn't spill out of boundaries. If the Light Pink starts to fill the empty space at the petal tip, that is okay.

Instructions

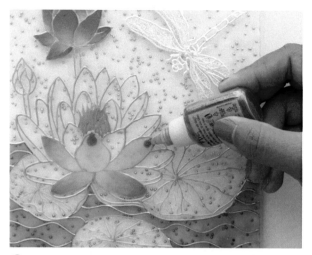

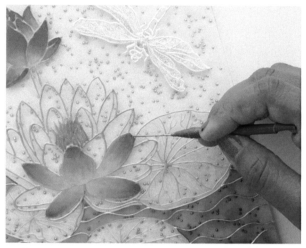

9 Add one to two drops of Pink glass paint to the petal tips. Mix using a pin, creating a gradient from Light Pink to Pink. Do not overfill the paint in a petal.

10 Repeat steps 6–9 for the rest of the petals. Let each group dry for a few minutes before painting another group. Repeat for medium lotus flower. Then paint the small lotus bud as if it were one petal, with Pink covering multiple sections at the top.

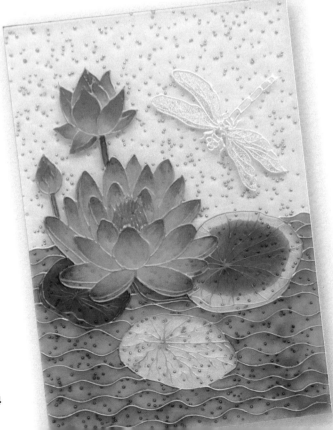

11 Mix Parrot Green glass paint (Crystal Green + Golden Yellow) in an empty small bottle. Shake well. Paint the lotus stems with Parrot Green. Then paint the left and middle lily pads directly under the large lotus. For the right lily pad, color in the center only.

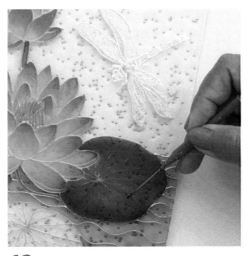

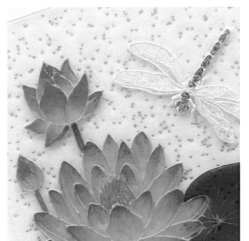

13 **Paint the dragonfly body with blue glitter paint.** In an empty small bottle, mix 3 Sea Blue glass paint + 1 blue glitter. Shake well. When the painting is complete, let it dry for 24 hours.

12 **Line the inner edges of the lily pad using Crystal Green glass paint.** Use a pin to mix the greens to get a beautiful and natural leaf color. Repeat for the bottom lily pad. If desired, add Crystal Green to the other lily pads and stems to create shading.

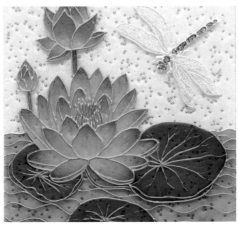

15 **Once the outlining is complete, let it dry for 24 hours.** Flip painting over to view the textured side; either side can be the front. Insert the glass in the wooden sign mount.

14 **Use Metallic Gold glass liner to line the gold lines again.** Use Metallic Silver for the silver lines. This will create a polished look for both sides of the piece.

Mod Floral Frame

DIFFICULTY: INTERMEDIATE

This custom photo frame uses quite a few techniques that you've learned so far. I recommend revisiting the Glass Paint Mixing Chart (page 29) and Glitter Glass Paint Mixing (page 30) if you need a refresher. You will learn a very simple color shading technique, which uses the same color of glass paint and glitter glass paint. For example, to color a yellow flower, you will use yellow glitter paint in the center or outer edges and yellow glass paint to fill in what remains. This project uses thin paints.

Practice color mixing with this project!

Materials Required:

- 8" x 10" (20 x 25cm) picture frame
- Glass paints:
 - White
 - Pink
 - Tomato Red
 - Orange
 - Golden Yellow
 - Crystal Green
- Glitters:
 - Pink
 - Copper
 - Orange
 - Yellow
 - White
 - Green
- Glass liner:
 - Metallic Gold
- Glitter glass liners:
 - Lime
 - Snow
 - Rose
- Small empty bottles
- Pattern (page 127)
- Tape
- Glass cleaner
- Cotton cloth, tissue, or napkin
- Cotton swab and pin
- Paper, aluminum foil, or other backing material

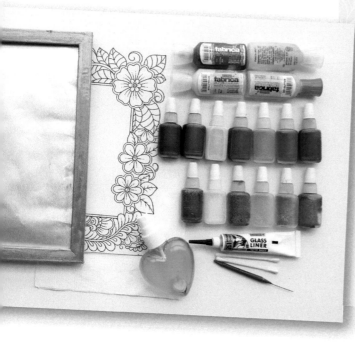

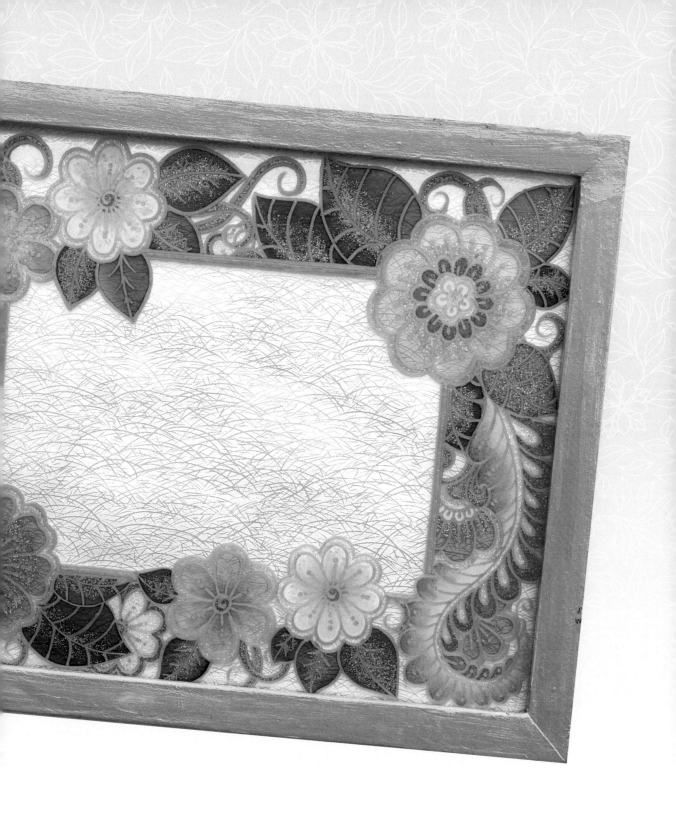

Instructions

1 **Separate the glass from the picture frame by unlatching the locking clips.** Clean the base using glass cleaner and a cotton cloth. You can either draw or print the pattern at the same or smaller size than the glass base.

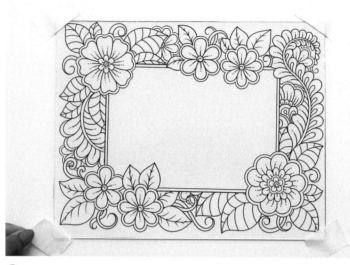

2 **Place the glass pane on the pattern exactly where you want the design to be.** I left a little extra room at the top and bottom to center the image. Secure the pattern to the glass using tape, then tape down all four corners of the glass.

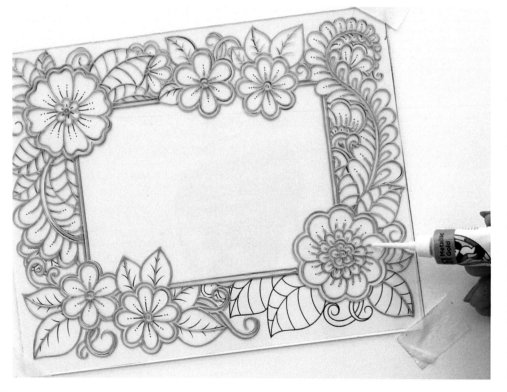

3 **Draw on the base using Metallic Gold glass liner.** Use the liner just like a pencil, tracing the lines of the pattern below. Select one element at a time, such as the petals or leaves, and outline part by part. Let it dry completely for 24 hours. Remove the tape and place the base on plain white paper on a horizontal surface.

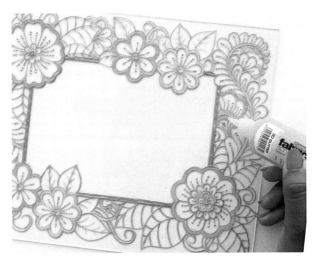

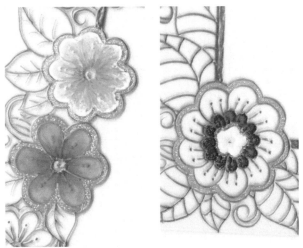

4 Use glitter glass liners to fill in the small or narrow designs of the flowers. I used Lime for the top-left, bottom-left, and middle-right flowers. Dot the centers of the top-left and bottom-right flowers with Lime. Outline the top-middle and bottom-right flowers with Rose. Use Snow for the top-right and bottom-middle flowers, as well as the middle of the bottom-right flower. Let it dry completely for 2–3 hours.

5 Paint the small sections on the flowers. Fill the center petals of the top-left and bottom-right flowers with White. Paint the tips of the top-right and bottom-middle flowers. Then fill the rest of those petals with Light Pink glass paint (White + Pink). Use a pin to mix the colors if they don't mix naturally. Paint the top-middle flower with Pink glass paint. Fill the middle petals of the bottom-right flower with pink glitter paint (3 Pink glass paint + 1 pink glitter).

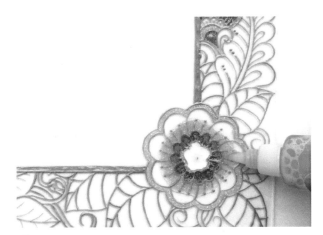

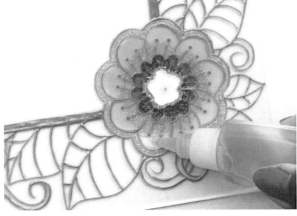

6 Use glitter to shade the bottom-right flower. Mix Coral glass paint (1 Tomato Red + 2 Pink), then mix 3 Coral glass paint + 1 copper glitter. Line the base of the petals with the Coral glitter paint.

7 Fill the rest of the bottom-right flower petals with Coral paint. The only difference in both paints used is the glitter, which is how glitter creates shading in the design.

Instructions

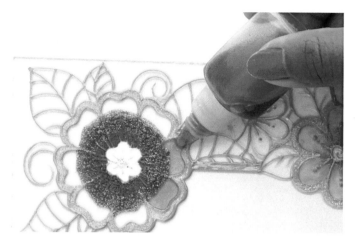

8 **Use glitter to shade the top-left flower.** In the same way as steps 6–7, use two glitter glass paints to shade. First, create a ring of orange glitter paint. Next, a middle ring of yellow glitter glass paint. Finally, fill the rest of the petals with Golden Yellow glass paint. Fill in the rest of the flowers with pink, yellow, orange, and white glitter paints.

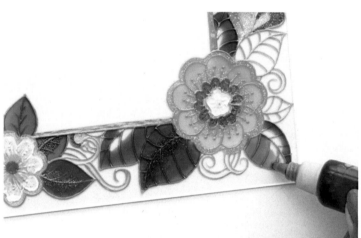

9 **Line the outside of a leaf with green glass paint.** I used Parrot Green (Crystal Green + Golden Yellow) for all the leaves. Only paint two to three leaves at a time. Fill in some leaves with solid Parrot Green glass paint.

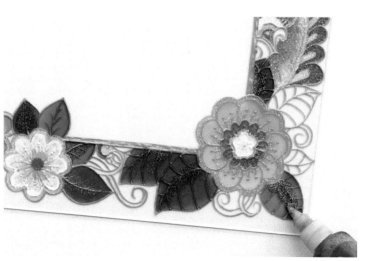

10 **Shade the leaf center with yellow glitter paint.** You can also use green glitter paint for the center to create a glitter shading effect. Use green glitter paint for the remaining tendrils.

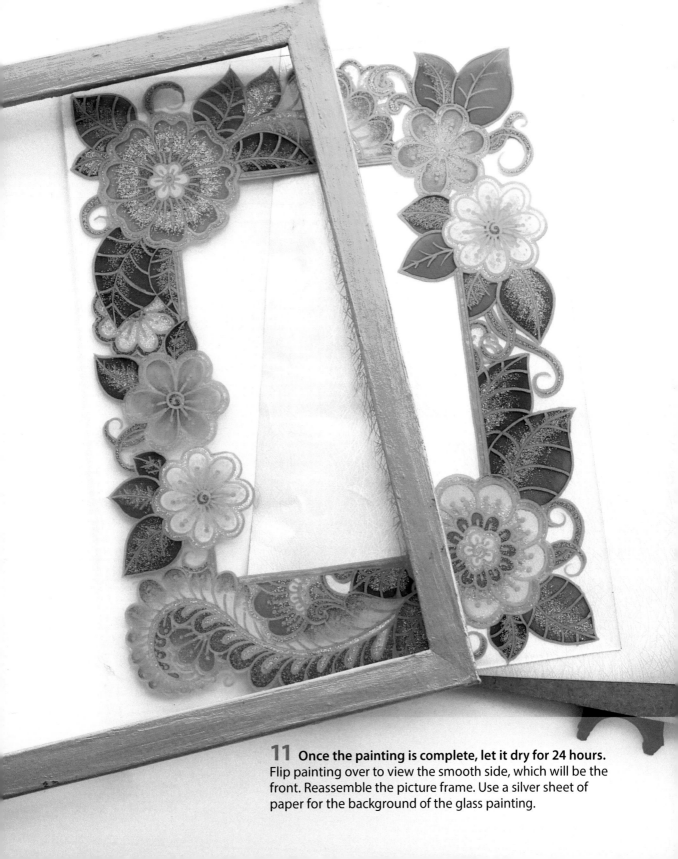

11 **Once the painting is complete, let it dry for 24 hours.**
Flip painting over to view the smooth side, which will be the
front. Reassemble the picture frame. Use a silver sheet of
paper for the background of the glass painting.

Sunflower Decorative Plate

Try another floral plate design!

DIFFICULTY: INTERMEDIATE

To create a design on a white plate, you will learn a new tracing technique then continue with glass painting as usual. Tracing, also called image transfer, uses a graphite or carbon paper to transfer an image from paper to another surface. Trace with a ballpoint pen or an embossing tool, following the lines of the design you want to transfer. Avoid making any unwanted lines or pressure on any other area of the carbon paper or else those marks will also transfer. When the paper is pulled away, ink will remain on the surface that is then easy to draw over with glass liners and paints. This project uses thin paints.

Materials Required:

- 13" (33cm) diameter white plate
- Glass paints:
 - Golden Yellow
 - Brown
 - Orange
 - Sea Blue
 - Pink
 - White
 - Crystal Green
- Glitters:
 - Yellow
 - Orange
 - Pink
 - Green
- Glass liner:
 - Gold
- Pattern (page 128)
- Pencil or pen
- Scissors
- Tape
- Carbon paper
- Embossing tool (optional)
- Size 2, 4, 6 paintbrushes
- Palette
- Glass cleaner
- Cotton cloth, tissue, or napkin
- Cotton swab and pin

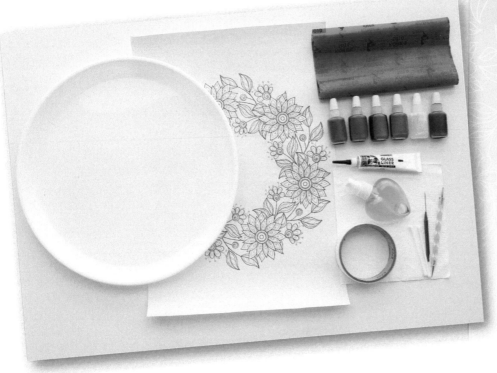

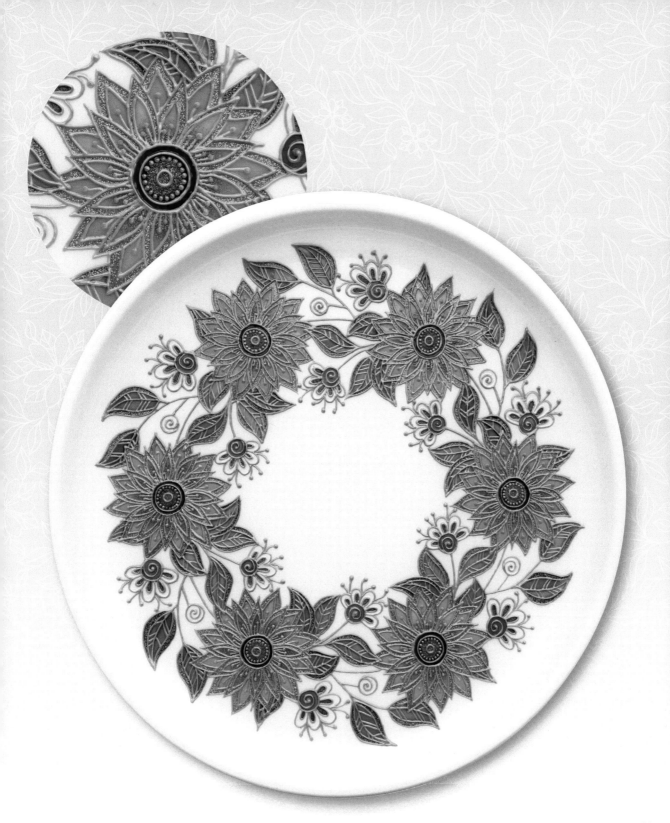

Instructions

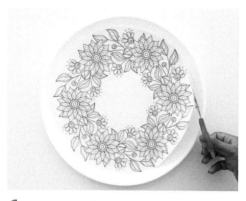

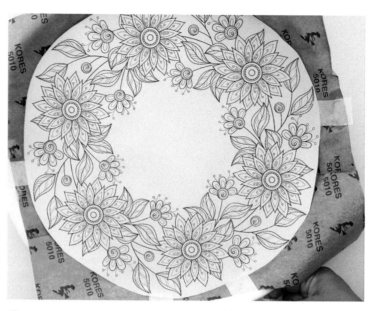

1 **Clean the plate using glass cleaner and a cotton cloth.** You can print the pattern at the same or smaller size than the base. Place the plate on the pattern paper, print-side down. Using a pen, outline the plate on the paper. Cut the circular pattern out so the design fits inside the plate.

2 **Place carbon paper on the plate.** If needed, tape two pieces of carbon paper together to cover the entire base. Use tape to secure the plate, carbon paper, and pattern from the sides so the pattern won't move. Cut the excess carbon paper so you don't accidentally leave marks on the edges of your plate.

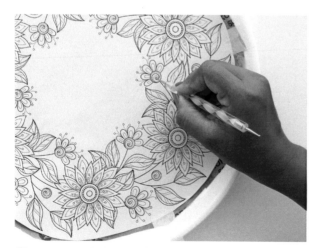

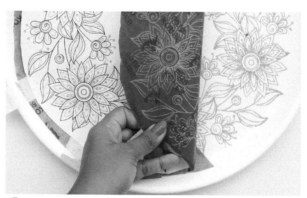

3 **Follow the lines of the design with an embossing tool or pen.** Pressing down will imprint the design on the plate. Trace part by part.

4 **After tracing is complete, remove one side of tape.** Check the impression is made properly. If any part is missing, tape the papers again and fill in that section of the design. When finished, remove all tape. Gently lift the carbon paper and pattern from one side of the plate.

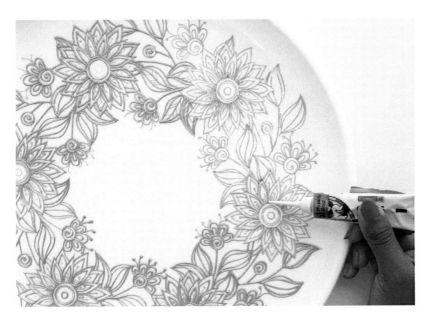

5 **Outline the design using Metallic Gold glass liner.** Use the liner just like a pencil, following the yellow lines left by the carbon paper. Start from one side and outline to the other end until complete. Let it dry completely for 24 hours.

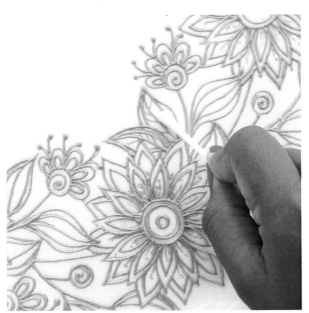

6 **Clean the carbon paper ink using a cotton swab.** This gives the plate a neat look that is ready for color.

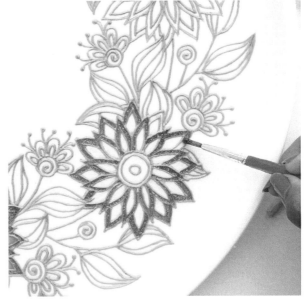

7 **Paint outer lines of sunflowers using a paintbrush.** Mix yellow glitter glass paint (3 Golden Yellow + 1 yellow glitter) in the palette. Use a paintbrush to carefully place the paint where you want it to go. Because the design is very fine and close, let this part dry, repeating this step on the next flower.

Instructions

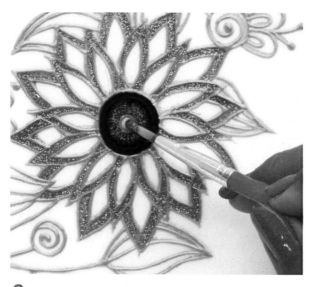

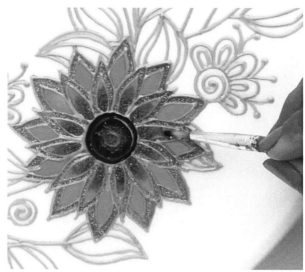

8 **Paint the center of the sunflower.** Fill the center rings with Brown glass paint, keeping the center circle empty. Then place orange glitter paint (3 Orange + 1 orange glitter) in the center, allowing the colors to mix in the small circle.

9 **Fill sunflower petals.** First use Golden Yellow glass paint, leaving some space at center edges. Then place orange glitter paint in that empty place. Mix the colors using a brush.

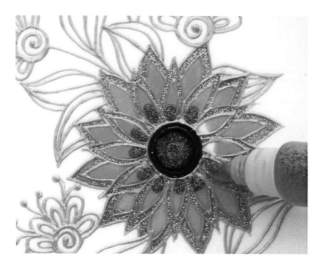

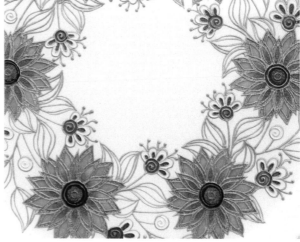

10 **Alternate method: Paint with bottles.** Pour directly from the bottle in the same order as step 9. Mix colors using a pin. Paint all the sunflowers using either method.

11 **Paint small flowers.** Use Purple glass paint (Sea Blue + Pink) for center, White for edges of petals, and Pink glitter paint (3 Pink + 1 pink glitter) for inner petals. Paint the small spiral circles with White.

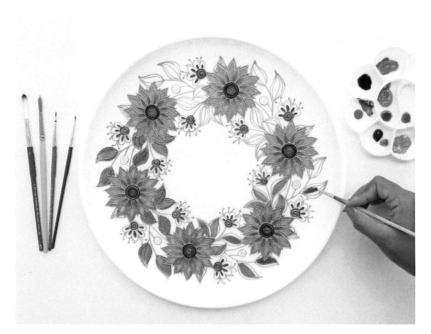

12 **Paint the leaves.** Use Parrot Green (Crystal Green + Golden Yellow) for the two inner sections. Paint outer sections with green glitter paint (3 Parrot Green + 1 green glitter). Once complete, let it dry for 24 hours.

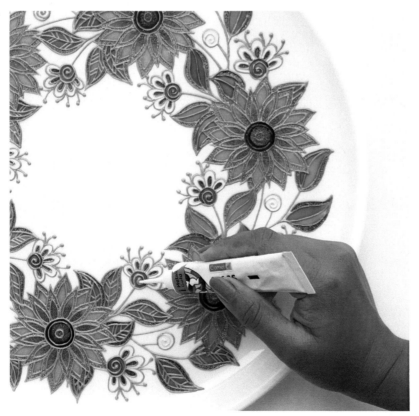

13 **Use Metallic Gold glass liner to line the gold lines again.** This will create a polished look for the places that were covered with paint. Once the outlining is done, let it dry completely for 24 hours.

Tulip Vase

DIFFICULTY: INTERMEDIATE

Use this technique on a fishbowl!

Materials Required:

- 11" (28cm) tall cyclindrical glass vase
- Glass paints:
 - Pink
 - Sea Blue
 - White
 - Tomato Red
 - Golden Yellow
 - Orange
 - Crystal Green
- Glitter glass liner:
 - Gold
- Small empty bottles
- Glass marking pencil
- Heat gun
- Patterns (page 129)
- Tape
- Scissors
- Glass cleaner
- Cotton cloth, tissue, or napkin
- Cotton swab and pin

Create a beautiful bouquet of tulips using different shades and colors of glass paints. This will pose a challenge since this is on a vase. Glass paints flow freely on smooth surfaces, and painting on a curved glass surface is completely different than painting on a flat piece. You must control and restrict glass paint by using glass or glitter liners, lest the color runs where you don't want it. Using a heat gun before and after painting helps lock the color in place. Only place the amount of paint on the glass that can be held within the liner. This project uses thin paints.

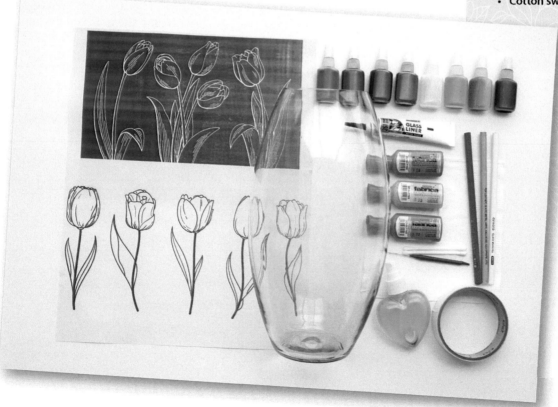

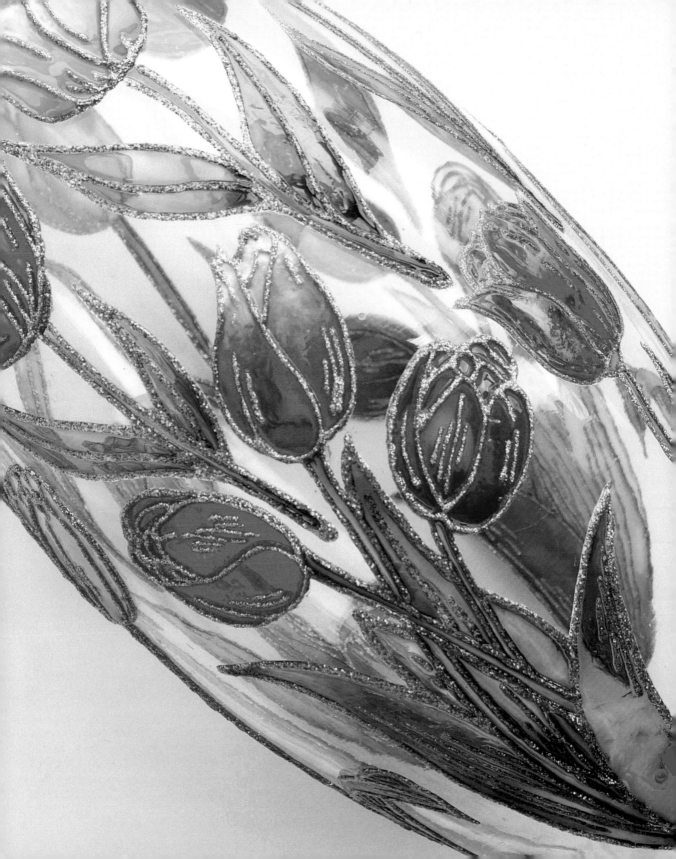

Instructions

1 **Clean the vase using glass cleaner and a cotton cloth.** This will make the surface clean and oil free.

2 **Draw or print the pattern at the same or smaller size than provided.** Cut flower designs from the pattern paper. You don't need to cut too close because they're for tracing, but make sure the extra paper won't overlap when planning your design. Attach pieces of tape to the corners of each tulip.

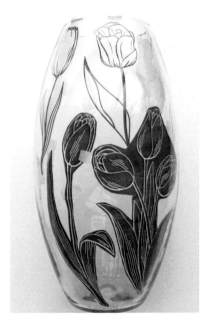

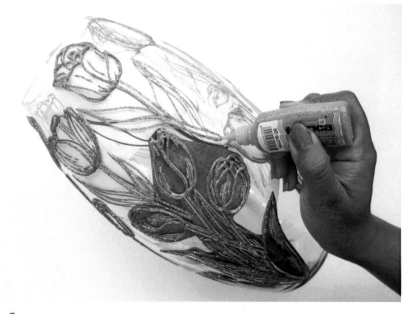

3 **Attach one print at a time to inside of the glass.** Place the pattern exactly where you want each flower to be. If needed, secure with extra tape.

4 **Trace one tulip using Gold glitter liner.** Use the liner just like a pencil, tracing the lines of the pattern below. Prop the glass up so the vase is as horizontal as possible. Let dry completely for 2–3 hours. Repeat for each tulip, gently rotating the vase. Make one flower at a time, drying between each one.

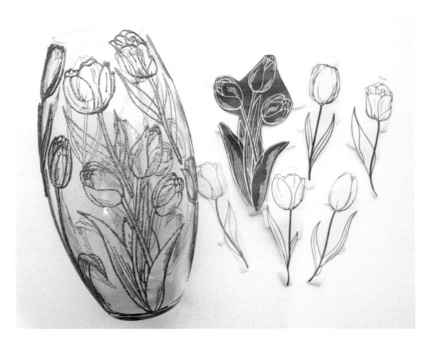

5 **When outlining is complete, let it dry for 24 hours.** Carefully remove the tape and patterns from the inside. Place the vase on plain white paper on a horizontal surface.

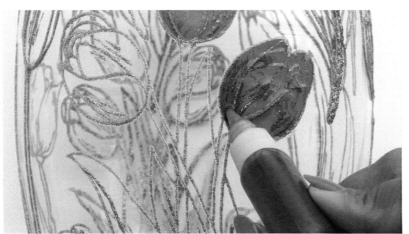

6 **With the heat gun, warm the glass surface for 1 minute.** Select two to three colors for each tulip, always using the light color first. For this tulip, I placed Pink glass paint at the top, then painted with Purple (Sea Blue + Pink) at the base of each petal.

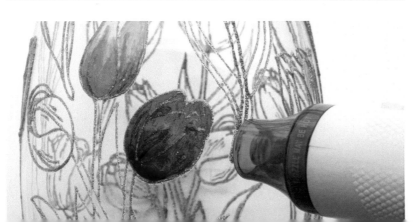

7 **Use the heat gun for 1 minute to partially dry the liquid glass paint.** This prevents it from flowing out of the glass liner. Let the flower dry naturally for 2–3 hours. This is mandatory for curved surfaces, or else the paint will run when working elsewhere on the glass.

Instructions

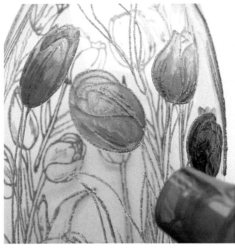

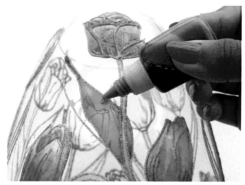

8 Paint the rest of the flowers following steps 5–6. Use different color combinations, such as White & Coral (1 Tomato Red + 2 Pink); White & Pink; Pink & Purple; Golden Yellow & Orange; White & Golden Yellow; and Golden Yellow, Orange & Tomato Red. Make sure to dry each flower before painting the next one.

9 Paint the leaves and stems. Heat the glass surface for 1 minute using the heat gun. Place Crystal Green glass paint at the base of the leaf or stem, then fill the rest with Light Green (Crystal Green + Golden Yellow + White). If needed, mix the colors with a pin to create a gradient. Dry the glass paint for 1 minute, keeping the heat gun at least 2"–3" (5–7.5cm) from the surface. Let the section dry for 2–3 hours. Repeat for the rest of the leaves and stems. When complete, let it dry for 24 hours.

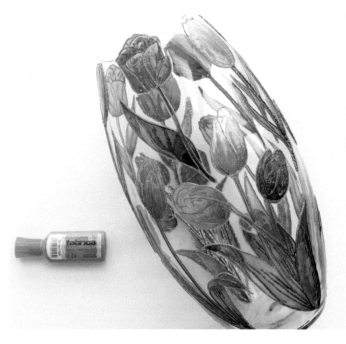

10 Use Gold glitter liner to line the gold lines again. This gives definition to the tulips. Once the outlining is done, let it dry completely for 24 hours.

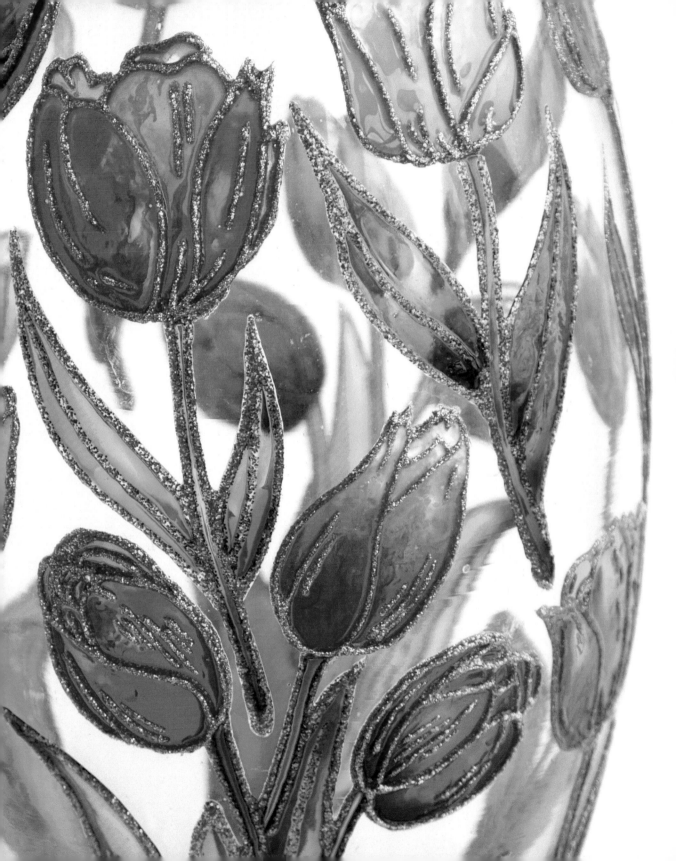

Rose Spray Mirror

DIFFICULTY: ADVANCED

Painting on mirrors is very similar to painting on glass. A mirror stands out more compared to glass because it both reflects light and allows light to pass through the colorful painting. Before painting, you can either draw directly on the mirror using a glass marking pencil or trace the reference design using graphite or carbon paper. In this project, you'll be using carbon paper. After lining and coloring using glass paints, let the paint dry completely, then repeat the glass lining to get a clear and finished look. This project uses thin paints.

Practice painting with this project!

Materials Required:

- 12" x 16½" (30 x 42cm) mirror
- Glass paints:
 - Pink
 - Tomato Red
 - White
 - Crystal Green
 - Golden Yellow
- Glass liner:
 - Gold
- Small empty bottles
- Pattern (page 130)
- Tape
- Carbon paper
- Embossing tool or pen
- Glass cleaner
- Cotton cloth, tissue, or napkin
- Cotton swab and pin

Instructions

1 **Clean the mirror using glass cleaner and a cotton cloth.** Print the pattern at the same or smaller size than the base. Place carbon paper on the mirror. If needed, tape two pieces of carbon paper together to cover the entire base.

2 **Place the pattern paper exactly where you want the design to be.** Use tape to secure all three (mirror, carbon paper, pattern) from the sides in a way that the pattern won't move.

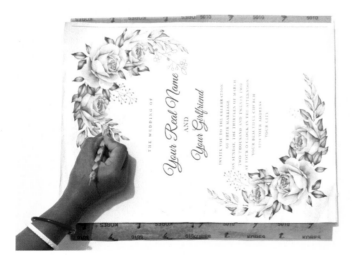

3 **Follow the lines of the design with an embossing tool or pen.** Pressing down will imprint the design on the plate. Trace part by part, starting at one side, without missing any line.

4 **After tracing is complete, remove one side of tape.** Check the impression is made properly. If any part is missing, tape the papers again and fill in that section of the design. When finished, remove all tape. Gently lift the carbon paper and pattern from one side of the mirror.

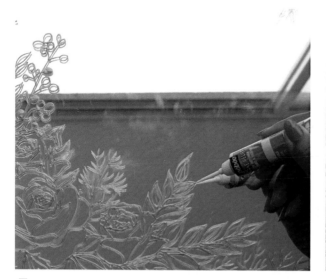

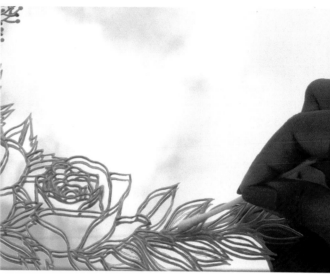

5 **Outline the design using Metallic Gold glass liner.** Use the liner just like a pencil, following the yellow lines left by the carbon paper. Start from one side and outline to the other end until complete. Let it dry completely for 12–24 hours.

6 **Clean the carbon paper ink using a cotton swab.** This gives the mirror a neat look that is ready for color.

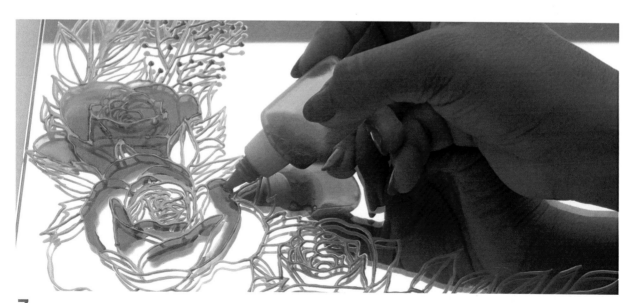

7 **Paint two left roses using Pink glass paint.** Line the outer edges of the petals. Then use Tomato Red to fill in. Mix both colors with a pin or brush to create a gradient. After coloring one rose, let dry it for 3–4 hours. Paint one flower at a time.

Instructions

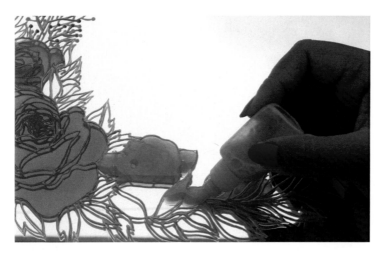

8 **Paint the right rose using White glass paint.** Line the outer edges of the petals. Then use Light Pink (Pink + White) for the next third of the rose. Always start shading with the light color first, then the darker color, as it automatically mixes together.

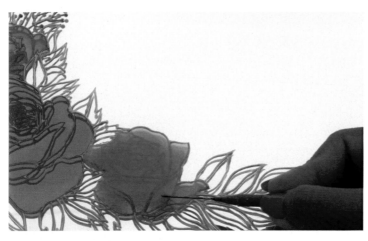

9 **Add a few drops of Pink to the base.** This gives the rose a natural look. Mix colors using a pin or brush. After painting all the roses, let them dry for 12–24 hours.

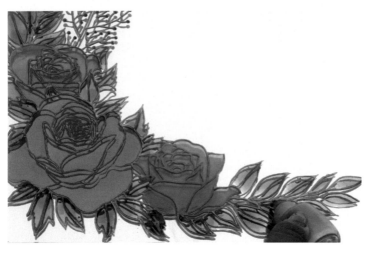

10 **Paint the leaves green.** Use Light Green (Crystal Green + Golden Yellow + White) on the leaf tips. Then use Parrot Green (Crystal Green + Golden Yellow) for the next third of the leaf. Finally, use a few drops of Crystal Green at the base. Use a pin or brush for mixing colors if needed. Let it dry for 24 hours.

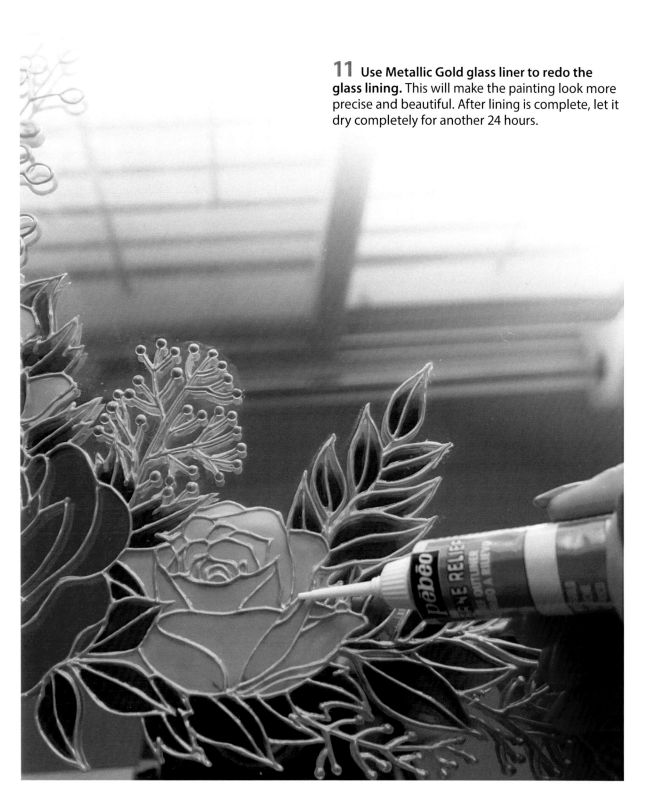

11 **Use Metallic Gold glass liner to redo the glass lining.** This will make the painting look more precise and beautiful. After lining is complete, let it dry completely for another 24 hours.

Floral Wreath Clock

Follow the video tutorial!

DIFFICULTY: ADVANCED

Paint beautiful peonies on a round clock using two to three different shades of colors in each flower. I recommend revisiting the Glass Paint Mixing Chart (page 29) and Glitter Glass Paint Mixing (page 30) if you need a refresher. The back of the clock and the painting are then sealed using clear resin, which will make the colors permanent. Complete your fully functional and gorgeous clock by attaching clock hands and a motor. This project uses thin paints.

Materials Required:

- 12" (30.5cm) diameter acrylic or cut-glass clock face
- Glass paints:
 - White
 - Pink
 - Tomato Red
 - Golden Yellow
 - Orange
 - Brown
 - Crystal Green
- Glitter:
 - Red
- Glass liner:
 - Metallic Gold
- Small empty bottles
- Size 2, 4, 6 paintbrushes
- Pattern (page 131)
- Tape
- Glass cleaner
- Cotton cloth, tissue, or napkin
- Cotton swab and pin
- Clock hands and motor
- Clock markers or numbers
- Epoxy resin
- Pearl-white resin tint or powdered pigment
- Resin tool set (page 26)

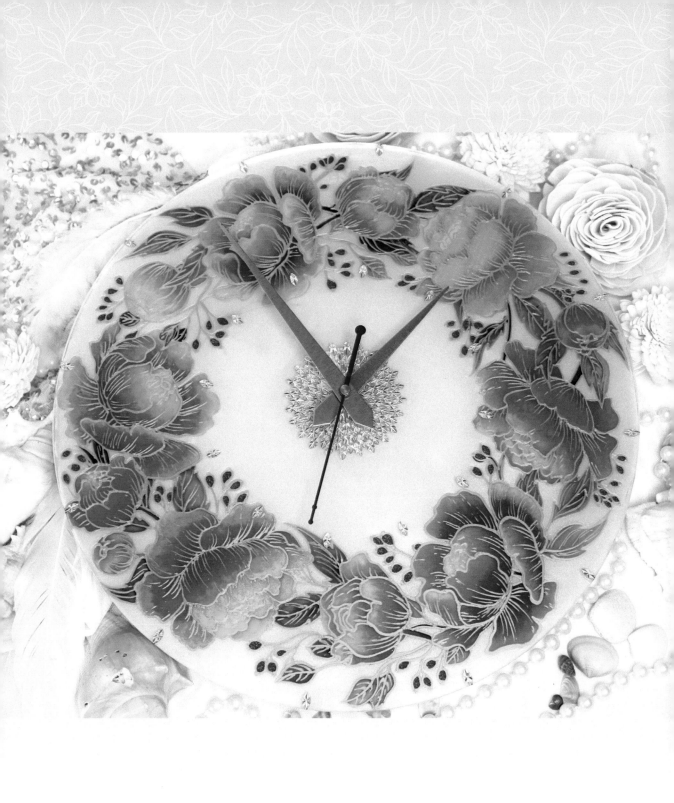

Instructions

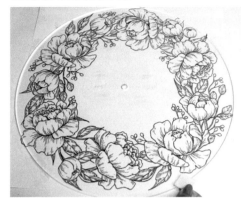

1 **Clean the base using glass cleaner and a cotton cloth.** You can either draw or print the pattern at the same or smaller size than the glass base. Place the base on the pattern exactly where you want the design to be. Secure both using tape.

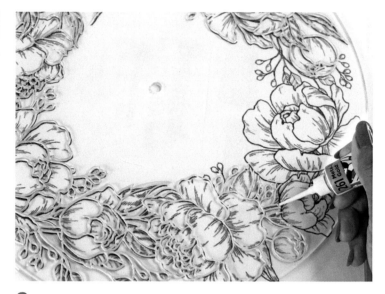

2 **Outline the design using Metallic Gold glass liner.** Use the liner just like a pencil, tracing the lines of the pattern below. Select one element at a time, such as the petals or leaves, and outline part by part. Let dry for 12 hours. Remove the tape and place the base on plain white paper on a horizontal surface.

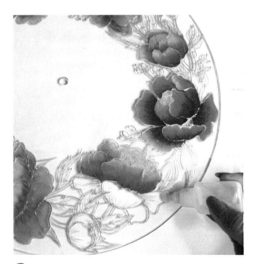

3 **Paint one petal at a time.** Select three colors for each flower. I used White, Pink & Tomato Red; White, Golden Yellow & Orange; and White, Pink & Maroon. First, fill in with the lightest color, White, from top edge of flower petal. Then add to the same petal with Pink. Mix White and Pink using a brush or pin to create a gradient.

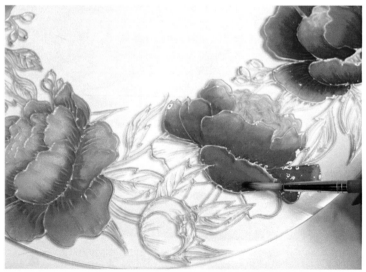

4 **Fill in with the darkest color.** Mix Tomato Red with Pink using a paintbrush. Color the rest of the peony according to the order chosen. Let the flower dry naturally for 2–3 hours. Paint the rest of the peonies.

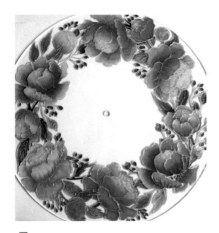

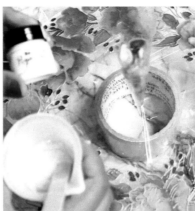

5 **In a similar manner, paint all the leaves.** Use various shades, such as Crystal Green, Parrot Green, and Light Green. For the flower buds, place a green at the base and Pink at the top. Do not mix the colors, allowing a line to form to replicate the greenery at the base of a peony bud. Fill in the berries using red glitter paint. Let the painting dry completely for 12–24 hours.

6 **Prepare the clock base before pouring resin.** Seal the center hole and sides using tape. I created a cone of tape to make it easy to remove from the center hole later. Raise the base from your work surface, which can be done by placing the roll of tape underneath.

7 **Mix clear resin in a cup.** Add ¼ teaspoon (1ml) pearl-white resin colorant in resin mixture. Mix it thoroughly for 4–5 minutes. This color will create a sheen to the base that is like using a shiny background paper. Once the resin mix is ready, pour it on the painting side of the clock base. Using a popsicle stick, spread it evenly to all corners of the base.

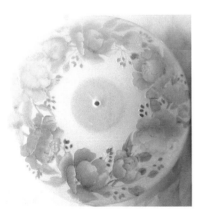

8 **Let resin cure for 24 hours.** Once the resin is completely dry, remove the center tape.

9 Affix a clock motor from the back and hands from the front. Turn the clock to the front. Place your clock markers or numbers; I used a few crystals to mark the time. You can also decorate the rest of the surface, as I did with my leftover crystals.

Butterfly Lantern

Try a curved lantern design!

In this project, make a dazzling lantern of butterflies and moths using glitter and glass paint. Using glitter in glass painting gives an exquisite and fascinating appearance to a piece. There are two ways to use glitter: first, add glitter in the bottle, and second, add glitter onto the paint using a spoon-shaped tool. Adding glitter with a spoon while painting gives you control to add more or less glitter, depending on what looks best. Secondly, you can add multiple shades of same-color glitter through mixing. Thirdly, it saves time when painting small and detailed sections. This project uses thin paints.

Materials Required:

- 11" x 4½" x 4½" (28 x 11.5 x 11.5cm) lantern
- LED fairy lights (optional)
- Glass paints:
 · White
 · Tomato Red
 · Pink
 · Sea Blue
 · Ultramarine Blue
 · Golden Yellow
 · Orange
 · Black
- Glitters:
 · White
 · Blue
 · Purple
 · Yellow
 · Black
 · Orange
- Glass liners:
 · Metallic Gold
 · Metallic Silver
- Glitter glass liners:
 · Magenta
 · Black
 · Snow
- Spoon-shaped tool
- Size 2, 4, 6 paintbrushes
- Palette
- Pattern (page 132)
- Tape
- Glass cleaner
- Cotton cloth, tissue, or napkin
- Cotton swab and pin
- Resin or varnish
- Resin tool set (page 26)

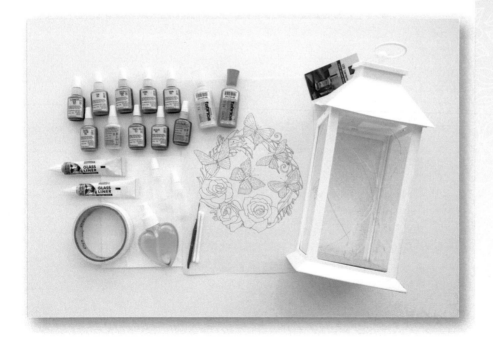

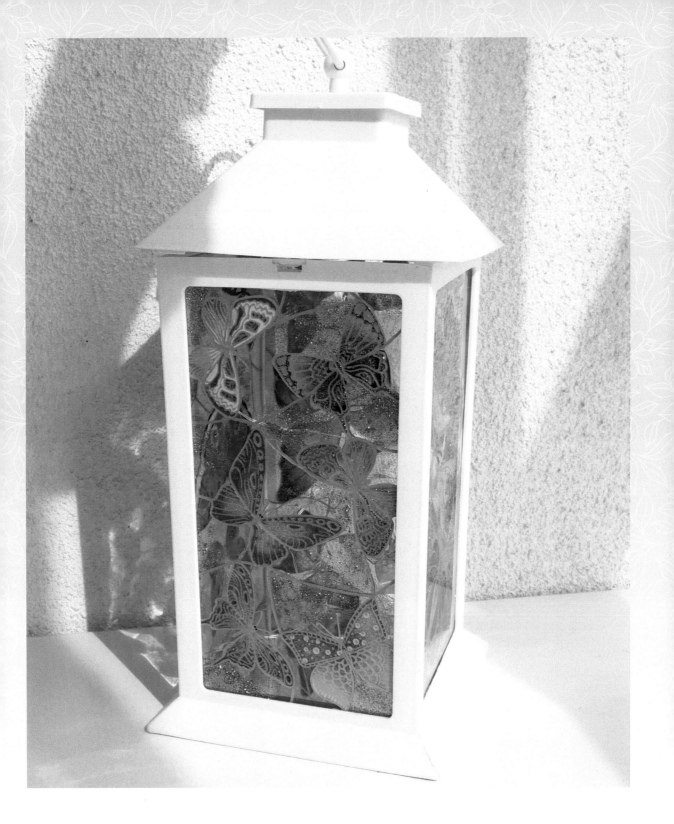

Instructions

1 **Separate the glass from the lantern by removing the top and sliding all four panes out.** Clean each one using glass cleaner and a cotton cloth.

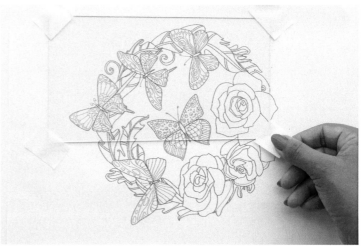

2 **Draw or print the pattern at the same or smaller size than the glass base.** Since you will only use the butterflies from this pattern, base your size on them rather than the rest of the pattern. Place the glass pane on the pattern exactly where you want the first butterfly to be. Secure both using tape.

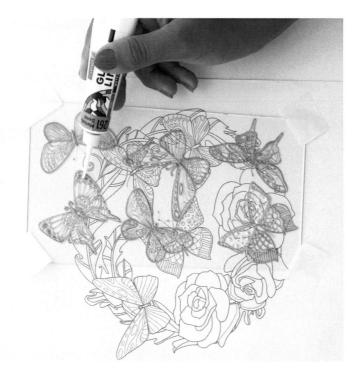

3 **Outline one butterfly using Metallic Gold glass liner.** Use the liner just like a pencil, tracing the lines of the pattern below. Let dry for 2–3 hours. Release the tape, move the glass on top of another butterfly, secure with tape, then outline with gold. Repeat until the glass is full. If desired, add details with Metallic Silver glass liner.

4 Repeat step 3 for the remaining glass panes. When outlining is complete, let all four panels dry for 24 hours. Remove the tape and pattern paper. Place the bases on a horizontal surface. If needed, insert a plain white paper under the glass to make it easier to see the lines.

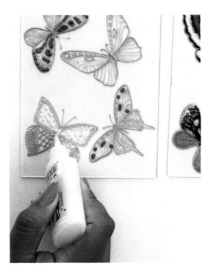

5 Fill in the small and narrow parts of the butterflies using glitter liners. I used Magenta, Black, and Snow liners to fill in the bodies, wing tips, dots, and stripes. Let dry completely for 2–3 hours.

6 Color small designs using a paintbrush and White glass paint. Pour only the amount of paint you need in the palette.

7 Add shading to wings. Start by pouring lighter shade then use darker color. Here, I paint Coral (1 Tomato Red + 2 Pink) for light color and Pink for dark color. Using a brush or pin, mix in between the colors to get shading.

Instructions

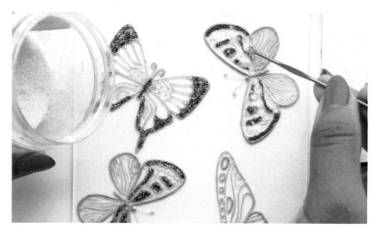

8 **Paint the section that will have glitter applied.** Place glass paint down first as a base; I used White here. Add white glitter on top using a small spoon-shaped tool. Use a small amount of glitter and place it on the glass paint. Pick only the amount of glitter you want to place; it can be less or more depending on the size of the section and how much glitter you want. Use a pin to adjust the amount of glitter.

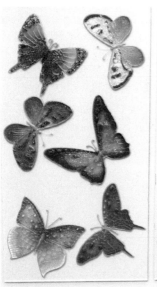

9 **Using the same methods as steps 5–8, paint the rest of the butterflies.** Try different paint and glitter paint color combinations to create unique designs. After completing the painting, let dry for 24 hours.

10 **Create lines with Metallic Gold glass liner.** Divide the designs into small sections. This gives the appearance of stained glass. Let it dry for 24 hours.

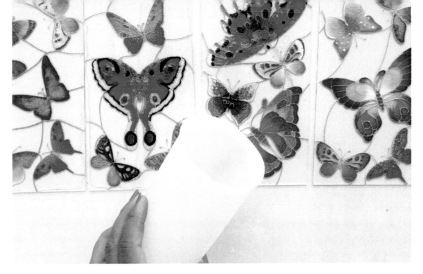

11 **Seal the glass paints.** Here, I use resin; you can also use varnish and follow the same steps. Mix some clear resin in a cup, then pour a small amount on the glass. Always follow all safety precautions and the manufacturer's directions on the products you use. Spread resin to all corners using a popsicle stick. If using clear varnish, you can spread it on the glass with a paintbrush.

12 **Drop gold glitter on few sections.** Spread it using the same popsicle stick if needed. Let the resin or varnish cure (dry) completely for 24 hours.

13 **Bring all the pieces of lantern together.** Put the glass panes back one by one, facing the painted side to the inside of the lantern and smooth side to the outside. Insert fairy lights before securing the top.

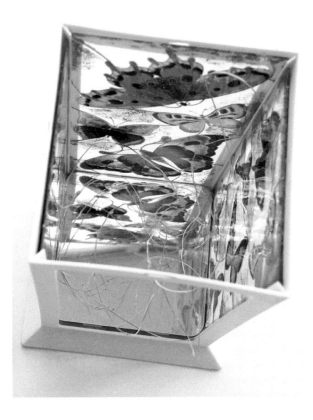

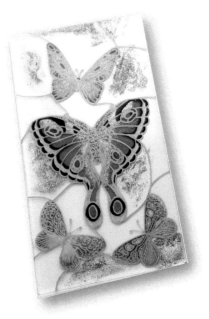

Dream Catcher Sun Charm

Learn how to make your own frame!

DIFFICULTY: ADVANCED

This project uses two unique bases: an acrylic circle and an Overhead Projector Sheet (OHP). An OHP Sheet is so thin and flexible that it can be folded or cut using scissors. This is how you can shape a glass painting. After painting on an OHP Sheet, cut the sheet to the required shape or size. You can create some original and fun shapes this way, such as the feathers used here as decorative charms. They will be attached with a chain and resin. While this sun charm uses monochromatic cool colors, you can go with warm colors or a palette of your choosing. This project uses thin paints.

Materials Required:

- 12" (30.5cm) diameter acrylic base
- A3 or A4 size OHP Sheet
- Glass paints:
 - White
 - Sea Blue
 - Ultramarine Blue
 - Black
- Glitters:
 - White
 - Light blue
 - Blue
 - Medium blue
 - Dark blue
- Glitter glass liner:
 - Black
- Small empty bottles
- Patterns (pages 133 and 134)
- Tape
- Scissors
- Glass cleaner
- Cotton cloth, tissue, or napkin
- Cotton swab and pin
- Silver chain
- Flat-nose and round-nose pliers
- Epoxy resin or strong glue
- Resin tool set (page 26)

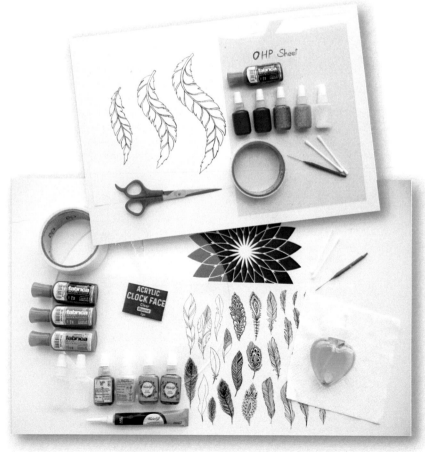

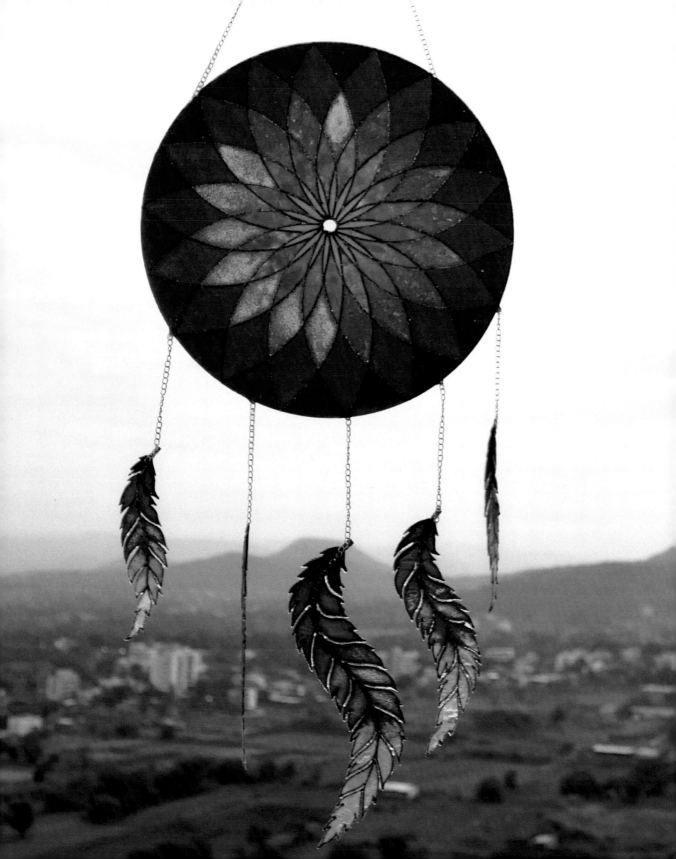

Instructions

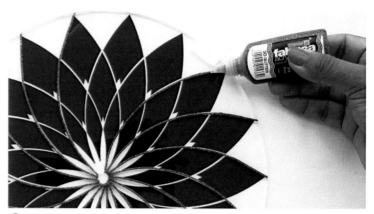

1 **Clean the base using glass cleaner and a cotton cloth.** You can either draw or print the circular pattern at the same or smaller size than the glass base. Place the base on the pattern exactly where you want the design to be. Secure both using tape.

2 **Outline half the design using Black glitter glass liner.** Use the liner just like a pencil, tracing the white lines of the pattern below. Follow one curved line at a time. Complete the left sides of each shape first, moving around the center in the same direction. Let dry for 12 hours.

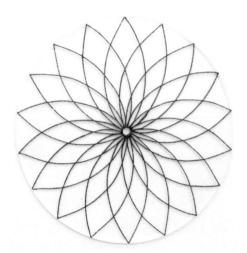

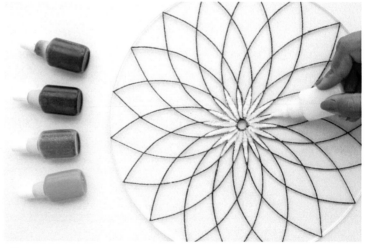

3 **Outline the second half on the design.** As before, trace one line at a time, moving in the same direction. Let it dry completely for 12–24 hours. Remove the tape and place the base on plain white paper on a horizontal surface.

4 **Create white glitter glass paint.** Mix 1 white glitter + 3 White glass paint in a small bottle. Shake well. Fill in the central ring of the design. Be careful when filling in the narrow edges of each shape, avoiding spilling into the other rings.

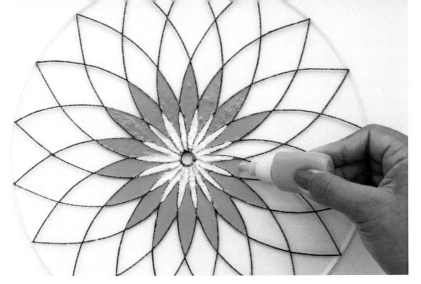

5 **Create a light blue glitter glass paint.** To create Light Blue glass paint, mix Sea Blue + White in a small bottle. Shake well. Then combine 3 Light Blue + 1 light blue glitter in a bottle and shake well. Fill the second ring of the design.

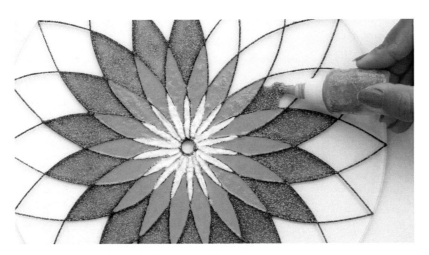

6 **Create blue glitter glass paint.** Mix 1 blue glitter + 3 Sea Blue glass paint in a small bottle. Shake well. Fill the third ring of the design.

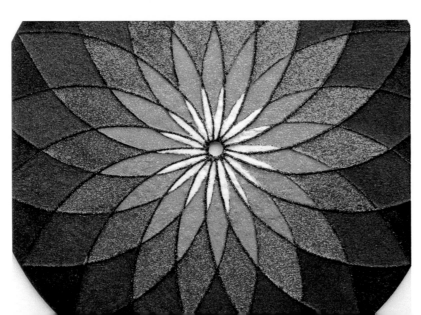

7 **Create ultramarine blue glitter glass paint.** Mix 1 medium blue glitter + 3 Ultramarine Blue glass paint in a small bottle. Shake well. Fill the fourth ring of the design. Create navy glitter glass paint. Mix 1 dark blue glitter + 3 Black glass paint in a small bottle. Shake well. Fill the outer ring of the design. When done, let dry completely for 24 hours.

Instructions

8 **Either draw or print the feather pattern at the same or smaller size than the OHP Sheet.** Place the sheet on the pattern exactly where you want the design to be. Leave one side empty so you have space to trace two of the feathers later. Secure the pattern and OHP Sheet using tape.

9 **Outline the feathers using Black glitter glass liner.** Use the liner just like a pencil, tracing the lines of the pattern below. Start by lining from one end to the other, one feather at a time. Let dry for 2–3 hours.

10 **Shift the OHP Sheet to the two smaller feathers.** Secure with tape. Outline with Black glitter liner as you did in the previous step. Once complete, let all feathers dry completely for 12–24 hours. Remove the tape and place the base on plain white paper on a horizontal surface.

11 **Fill the feathers with the glitter paints made in steps 4–7.** Paint one section at a time, starting with navy at the top and transitioning to white at the bottom. In a few sections, fill each half with a different color and mix. This will create a smooth gradient through the entire feather. Color patiently without crossing boundary lines. Once the painting is complete, let it dry for 24 hours.

12 **Cut the feathers out one by one.** Keep as close to the liner as possible. Place circular base and feathers on a horizontal work surface.

13 **Separate the silver chain into pieces for each section.** Create five 6" (15cm) pieces for the feathers, and one 24" (61cm) piece to hang the main piece. Use pliers to separate chain links. Lay the pieces out first to make sure everything is as you want it. Set chains to the side; you will be using them soon.

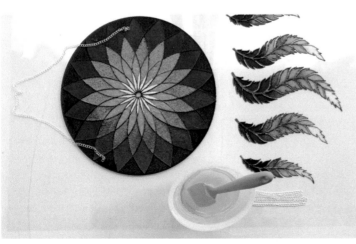

14 **Mix clear resin in a cup.** Pour a small amount of resin on the circular base. Spread resin to all edges using a spatula. Do not overflow the clear resin from base. Be very patient while handling resin. Always follow all safety precautions and the manufacturer's directions on the products you use.

Instructions

15 **Attach long chain to top of circular base.** While resin is still wet, place one end of the chain in the resin, letting it settle. Line it up with the curves of the glass liner, as shown. Repeat with the other end. Make sure at least 2" (5cm) of chain is in the resin to ensure there is enough support to hold the piece.

16 **Pour a small amount of resin on the feathers.** Seal one feather at a time. Spread resin to all edges using a spatula.

17 **Attach five small chains on bottom of circular base.** While resin is still wet, place each end an equal distance apart. Only two or three chain links need to be attached. While resin is still wet, place the other end of each chain on the feathers. Line up four chain links with the centerline of the feather. Let the resin cure for 24 hours or more. Once the resin is completely dry, you can pick up the sun charm.

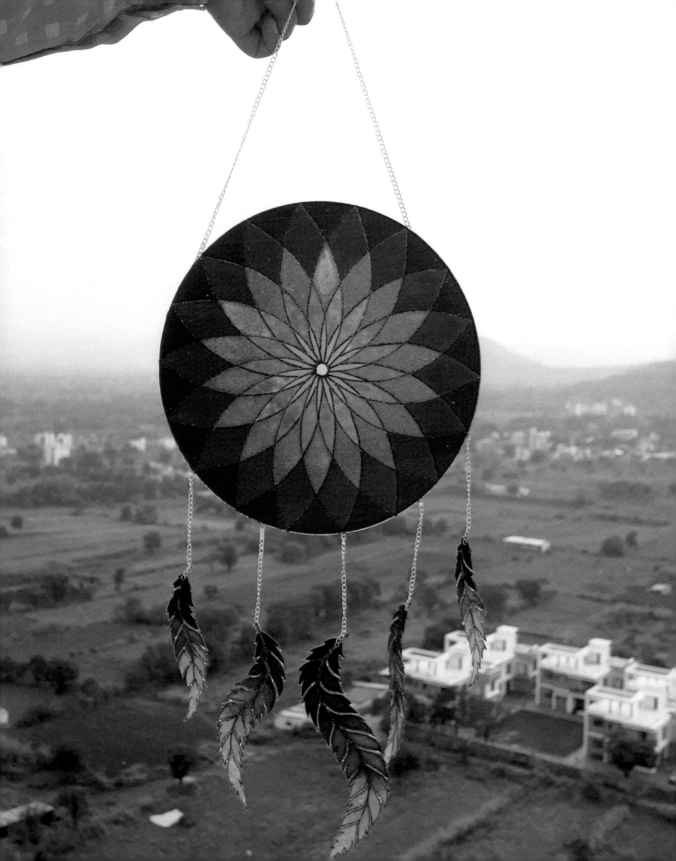

Patterns

Girl in Love

(see page 34)

Photocopy at 100%.

Stained Glass Frame

(see page 38) Photocopy at 100%.

Ice Cream Cone

(see page 42)

Photocopy at 100%.

Selfie Couple

(see page 46)

Photocopy at 100%.

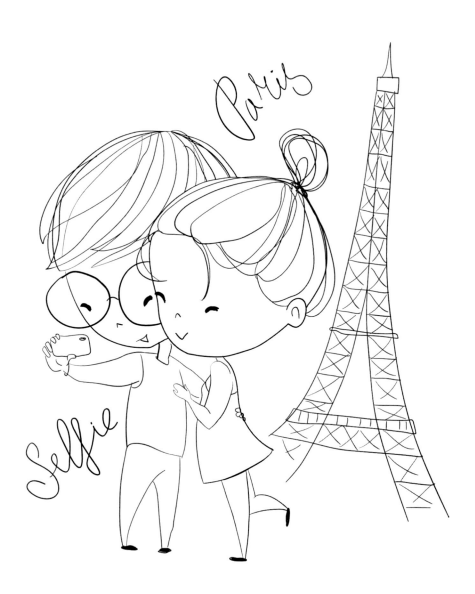

Rose Frame

(see page 50)

Photocopy at 150%.

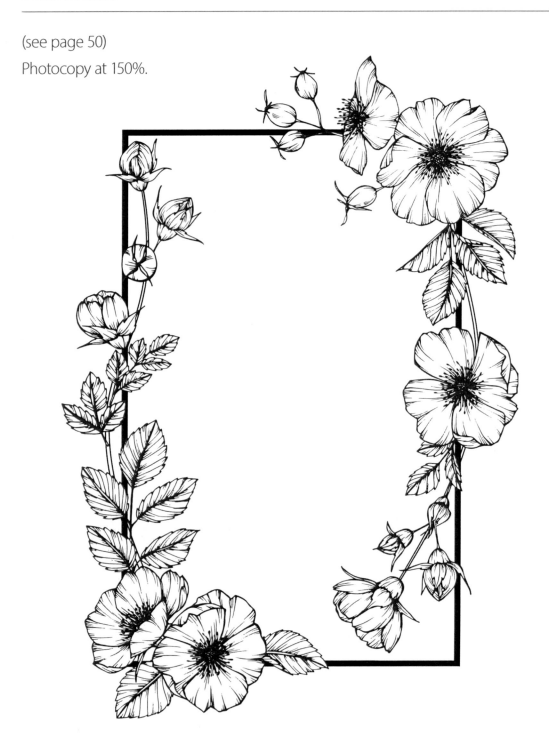

Hydrangeas

(see page 54)

Photocopy at 125%.

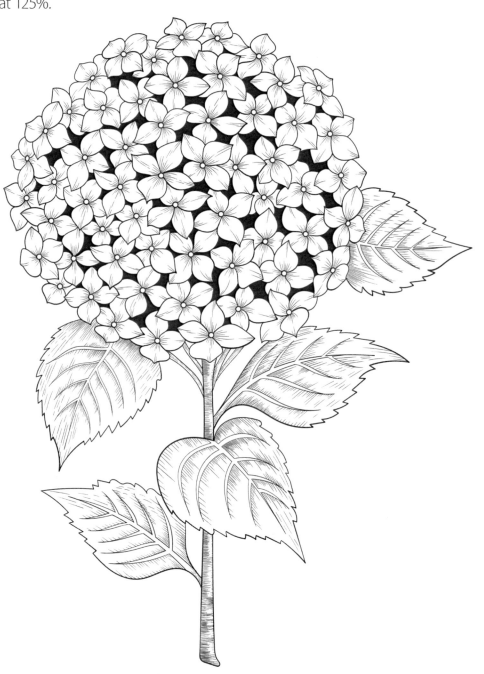

Floral Drinking Glass

(see page 58)

Photocopy at 100%.

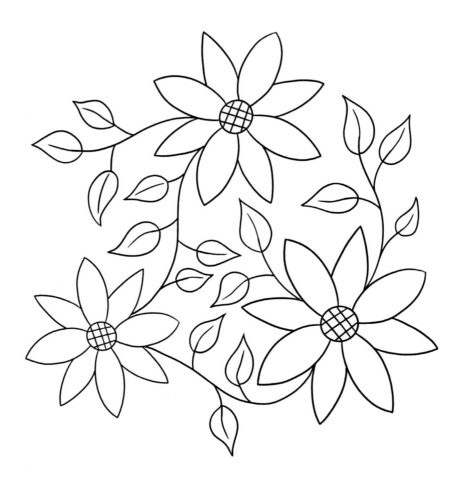

Unicorn

(see page 64)

Photocopy at 167%.

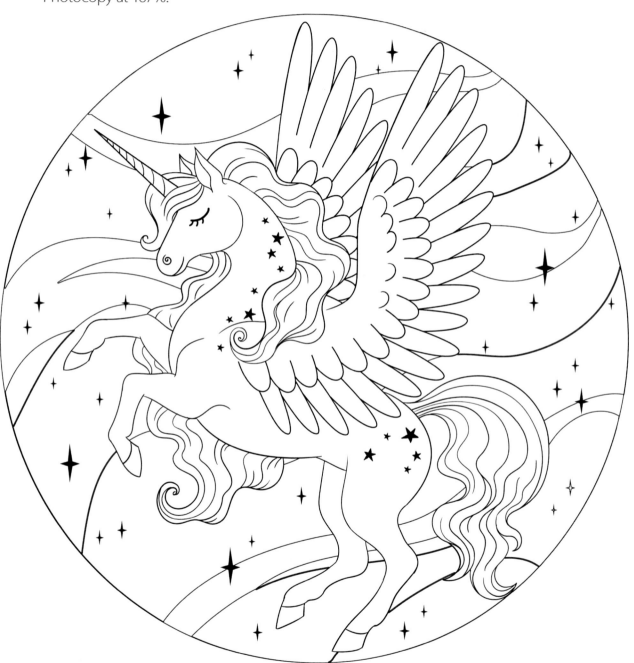

Lotus on Textured Glass

(see page 70)

Photocopy at 100%.

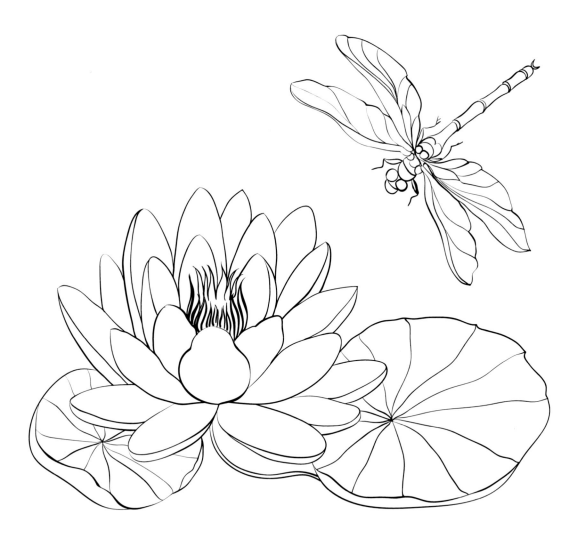

Mod Floral Frame

(see page 76)

Photocopy at 150%.

Sunflower Decorative Plate

(see page 82)

Photocopy at 167%.

Tulip Vase

(see page 88)

Photocopy at 200%.

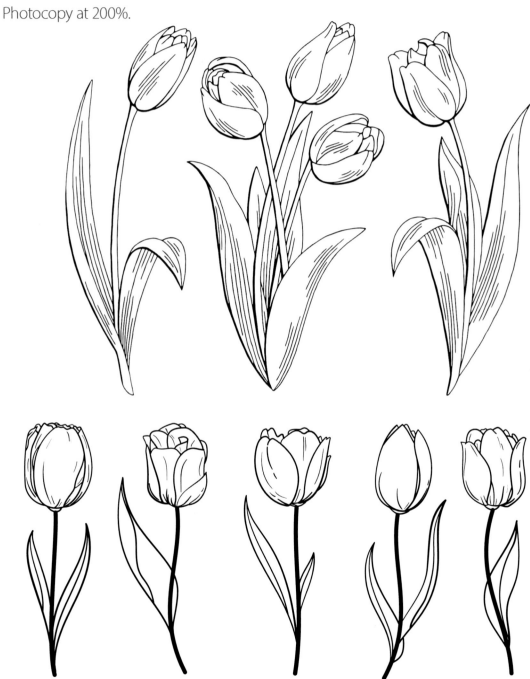

Rose Spray Mirror

(see page 94)

Photocopy at 150%.

Floral Wreath Clock

(see page 100)

Photocopy at 200%.

Butterfly Lantern

(see page 104)

Photocopy at 150%.

Dream Catcher Sun Charm

(see page 110)

Photocopy at 200%.

Dream Catcher Sun Charm

(see page 110)

Photocopy at 200%.

About the Author

Nilima Mistry lives in Pune, India, with her husband. She has a professional degree in software engineering though she has always had a passion for art. Her creative pursuits lead her through many mediums, including but not limited to glass painting, clay art, decoupage, and watercolor. For Nilima, art is a form of freedom, allowing her to express her thoughts and feelings. She knows art can change lives and the way one looks at the world, which lead her to teaching.

In 2016, Nilima started a channel on YouTube (@CreativeArt_Nilima), uploading videos for artists of all skill levels. In the years since, she's found great success. Nilima has published about 400 art tutorials, including about 150 glass painting tutorials. She currently has more than 250K followers on YouTube and views totalling in the millions. She has founded her own business, Creative Art, where she sells original artwork and teaches others how to create art across many mediums.

Nilima always continues to learn, having recently completed a certification in sculpture painting from Evgenia Ermilova School. She is currently working on a collection of plate wall decorations for an upcoming art exhibition. But she also loves to spend her time with some of her other hobbies, such as gardening, flower arranging, cooking, and baking. Nilima also loves traveling to different places to know their rich history of art and culture, which inspires her to make beautiful paintings.

For more of her work, visit www.creativearthome.com.

Index

Note: Page numbers in **bold** indicate artists and items featured in gallery. Page numbers in *italics* indicate projects and patterns (in parentheses).